JARROW

From Old Photographs

PAUL PERRY

AMBERLEY

Acknowledgments

I am grateful to the following people and organisations for their assistance in the preparation of this document.

Newcastle Chronicle & Journal, South Tyneside Libraries, Newcastle City Library, David Morton, Norman Dunn, Lawrence Cuthbert, Kevin Scott, Tom Carlisle, Dominic and Maureen Di Paolo, Stephen Hepburn MP, Malcolm Perry, Tom Quinn, Fr Gerard Martin, and Alan Murphy and Jenny Stephens from Amberley Publishing.

For My beautiful grandchildren
Jack & Eva Snowden in Sydney, Australia

First published 2017

Amberley Publishing
The Hill, Stroud
Gloucestershire, GL5 4EP

www.amberley-books.com

British Library Cataloguing in Publication Data.

A catalogue record for this book is available from the British Library.

ISBN 978 1 4456 7278 6 (print)
ISBN 978 1 4456 7279 3 (ebook)

Origination by Amberley Publishing.
Printed in the UK.

Foreword

As a 'Jarra Lad' born and bred it gives me great pleasure to endorse Paul Perry's new book 'Jarrow from Old Photographs'. This is a must-buy for all past and present Jarrovians.

I always look forward to taking a nostalgic tour of Jarrow illustrated by old photographs of the town, selected from Paul's unique and extensive collection. The images feature street scenes, notable buildings, social history, industry, events and transport. Jarrow is renowned as a town built on shipbuilding and steel working, courtesy of the Palmer shipbuilding empire who reigned supreme, supplying the world's fleet with more than 1,000 vessels until its demise in the 1930s. It was this abrupt closure of the world-famous shipyard that instigated the Jarrow Crusade. Paul's extensive collection of photographs has multiplied into many thousands of images, some of which he shares with us within the pages of his new book.

There is something for everyone here, whether you have lived in Jarrow all of your life, or whether you are just visiting this fabulous town.

Well done Paul – Jarrow's 'Very Own Historian'.

Stephen

Stephen Hepburn, MP for Jarrow

Introduction

I was delighted to be given the opportunity to write another volume for Amberley, using a selection of photographs from my archive. I am well aware of the pleasure people get from the many publications available on the fascinating subject of local history, not to mention the encouraging comments I receive to my personal contribution to the many bookshelves and attics they currently adorn. These glimpses of times gone by have become very popular in recent years, but as towns, villages and cities reveal very few changes over short periods of time, some of these changes on the urban landscape are so insignificant, they often go unnoticed, which of course makes photographing these minor alterations a challenge.

The major changes in the history and traditions of our town are ancient and at the same time often fragmentary until around the fifteenth century. Little is known of the habits of the Gyrwe tribe who frequented these shores prior to the time of Bede and the 600 Benedictine monks who occupied the ancient monastic site, and the visitations of the marauding bands of Viking warriors who graced us with their presence on a couple of occasions during the ninth century. It was during their second invasion in AD 866 that the monastery was plundered so severely it had to be abandoned and lay desolate for in excess of 150 years. In 1075, several attempts were made to restore the monastery, but they were unsuccessful. As the decades passed, further attempts of restoration to the decaying monastery were made without success, having suffered irreparable damage. As a consequence, the Roman and Saxon remains were abandoned and have lain undisturbed for centuries.

Benedict Biscop commenced the manufacture of stained glass as far back as the seventh century. The formal industrialisation of Jarrow commenced around the fifteenth century with rope and sail making, and the recovery of salt from the mineral-rich waters of the North Sea, and later in 1618 the primitive recovery of coal from a narrow but lucrative seam. But it was industrialist and entrepreneur Simon Temple who in 1798 first laid down the building blocks that commenced modern Jarrow's industrial growth with shipbuilding, at Dunkirk Place, and again in 1803 with coal mining at the infamous Alfred Pit. It was Temple's lavish lifestyle, free spending and reckless business decisions that led to his inevitable bankruptcy. He died penniless at the home of one of his former manservant's in 1822 aged sixty-three, a sad end to a great industrialist who contributed so much to the development of Jarrow.

The transformation of the town in 1851 is most certainly attributed to perhaps one of the country's leading industrialists of the day, shipbuilder Charles Mark Palmer. The Palmer empire success story was aided with the use of a unique steel rolling process, and an impressive galvanising plant renowned as being the biggest in the country. The 140-acre shipyard reached the heights of an integrated industry, housing 8 miles of internal railway and boasting the biggest foundry on the whole of the east coast. It had long been the boast of Jarrovians that 'at Palmers they take iron ore in at one end of the works, and sail a ship out of the other'. In excess of 1,000 ships sailed from Palmer's in its eighty-two-year history, equivalent to 2 million tonnes. But yet, nothing lasts forever. By 1934 it was all over.

North-east England for many years had been recognised as the cradle and school for all that is best in marine engineering. But Palmer's was unable to cope with the economic climate of the late 1920s, which brought upon the collapse of the company and the town's economy. In 1934, Jarrow was in a state of inactivity, insecurity and depression; our precious shipbuilding industry had been taken away and consigned to the history books. The town was in a desperate situation, as 80 per cent of the town's male working population found themselves on the scrapheap. It was the feelings of anger and total despair that brought about the organisation of the Jarrow Crusade in 1936.

The wonderful response in this country and from overseas to Jarrow's cry for help during the dark days of the depression cannot be written as fully as it truly deserves to be. The extent of assistance is unknown to any single individual and may never be known in full. Much could be written of the industries in Jarrow today with pride, as Jarrovians are as proud today of the town as their ancestors were when ship after ship was launched during those wonderful days of triumph and glory.

Paul Perry, 2017

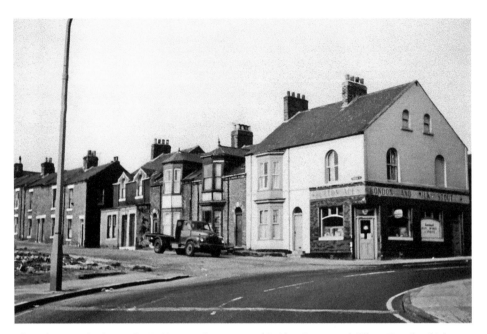

This photograph shows the Bridge on the corner of Bridge Street and Albert Road, which was built as a public house and the only pub in Jarrow that never actually served beer, as it was never granted a license. A Victorian bylaw did not permit licensed premises in this part of town. It did, however, sell intoxicating liquor, but only as an off-licence.

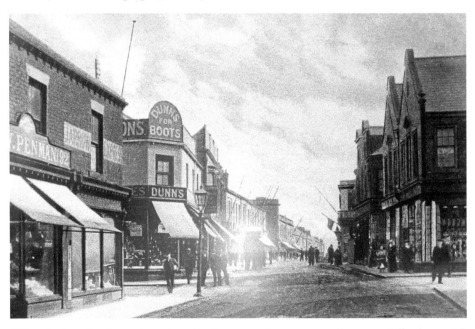

Although shopping in modern times is pleasant and more convenient, especially those with pedestrian-only precincts and malls, it seems to have lost all their character and charm. This view of Ormonde Street from 1898 was the town's major shopping street, prior to the arrival of the Arndale Centre. It became one of the main thoroughfares for the forthcoming tram service, which commenced in 1906.

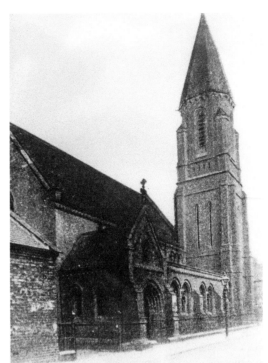

This is very likely to be the only photograph of St Peter's Church complete with spire. The spire was demolished by a wandering barrage balloon, which broke free from its moorings in a nearby gas yard. As funds were not available to repair the 117-foot spire, it remained this way until the building was demolished in 1963. The photograph dates from 1900.

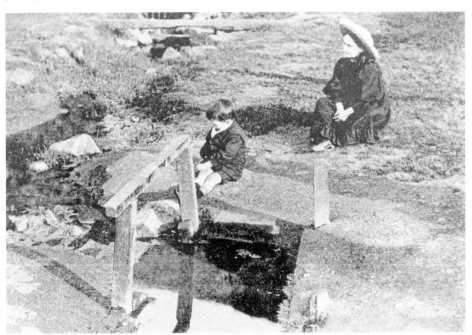

The ancient spring of St Bede, to give it its official title, is more commonly known as Bede's well. For centuries it has been associated with strange customs and ceremonies. One of these customs, from as recent as 1740, was to bring sick children to the well seeking a cure from the water, which was thought to have magical powers. It was common belief that this was the monk's water source. In fact, it is most unlikely Bede knew of its very existence.

York Avenue was officially opened by HRH Queen Elizabeth, the Queen Mother, in 1928, the dual carriageway said to be the first in the country. Traffic calming measures were introduced around twenty years ago, reducing it to single carriageway status. The accompanying photographs are at the junction of Butchers Bridge Road.

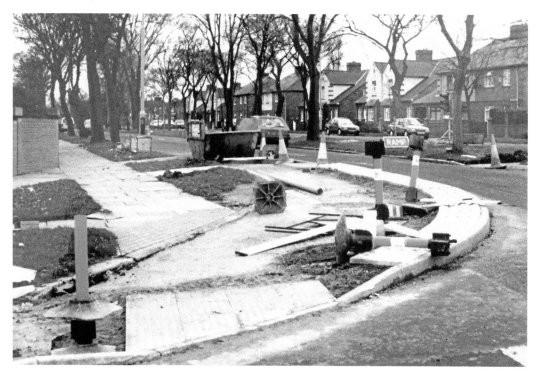

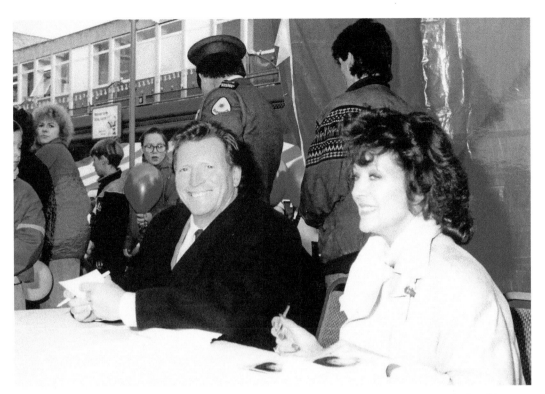

The Arndale Centre has been refurbished and has changed ownership several times in the last fifty or so years. The Arndale name was dropped during the 1980s in favour of the Viking Centre, and was officially opened by Coronation Street's Mike and Alma Baldwin. Further modernisation occurred in 2000.

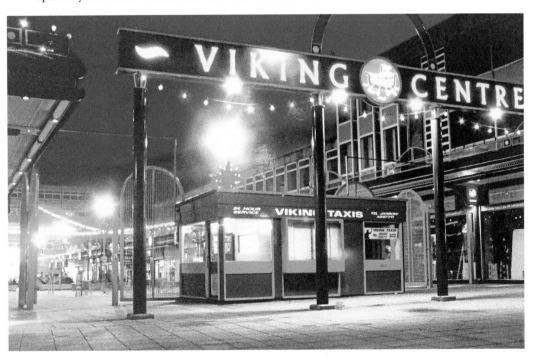

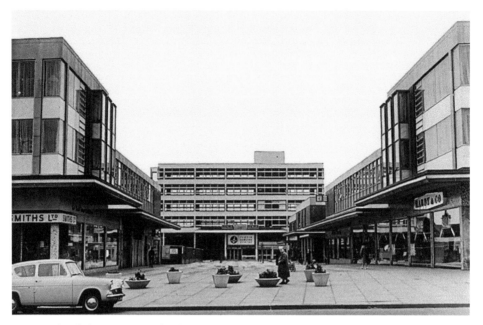

As a result of the post-war redevelopment programme, much of Jarrow was in a transitional state. Plans had been prepared as early as 1952 for a traffic-free shopping complex. All that was required was somewhere to put it. The site chosen was central to all amenities. Building work on the Arndale Centre commenced in 1955, with phase one (pictured here) opening in 1961.

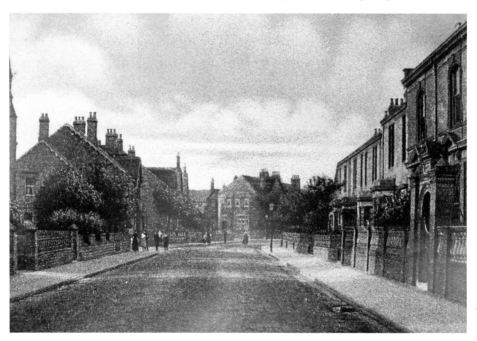

Jarrow has changed significantly during the twentieth century, so much so that parts of it are barely recognisable. Bede Burn Road, however, seems to have escaped the town planners. Apart from the introduction of a one-way system during the 1960s, the Victorian thoroughfare remains largely the same as it did when this photograph was taken in 1900.

Paper was manufactured at Springwell from 1841 by Thomas Bell until 1860, when the mill was purchased by William Henry Richardson, who continued the paper making tradition until his untimely death in 1923. The decaying mill lay abandoned until 1934, when it was used as an instruction centre. From 1950, various companies occupied the site for storage until 1998, when it was developed for private housing Mill Dene View.

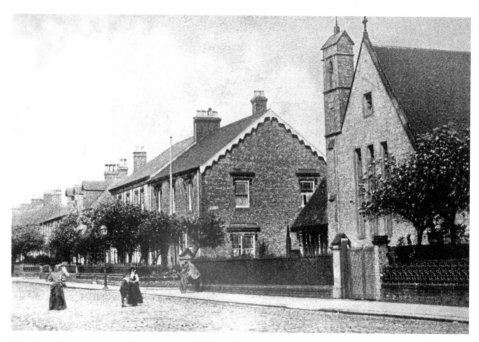

Another of our streets that seemed to dodge the bulldozers is Park Road. The grand Victorian residences look as elegant today as they did over a hundred years ago. The church to the right of this 1899 photograph, Chapel of the Good Shepherd, was demolished during the 1970s. The site was cleared, making way for housing.

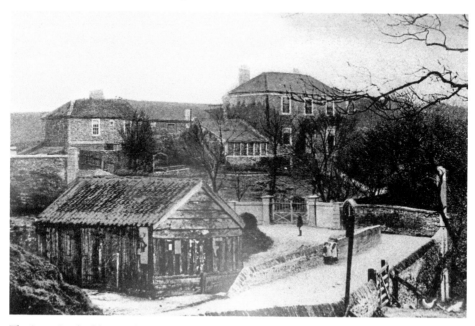

The imposing building in the centre of this photograph from 1896 is Hedworth Hall. It was the private residence of market gardener Robert Jobling. In 1930, the hall was purchased by Mary Harris, who carried on the business of market gardening. The barn in the foreground was part of Mill Farm owned by John Fisher – not surprising the area became known as Fishers Dene.

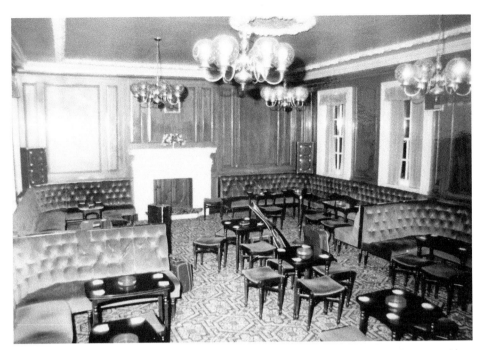

St Bede's Parochial Men's Club in Chapel Road opened in December 1947. It was governed by the parish council and an appointed committee. In 1977, a looming dereliction order placed by the town council on the premises put the future of the prosperous club in doubt. The building at this time was showing signs of decay and neglect, forcing the parish council to make a decision about the club's future. After searching for suitable properties it was decided the vacant former Jarrow & Hebburn Co-op office block in Albert Road offered great potential, and was the ideal venue. Many alterations were necessary in order to meet with building regulations; however, the beautiful oak panelled boardroom remained intact. A financial crisis in 1995 forced the closure of the once popular club.

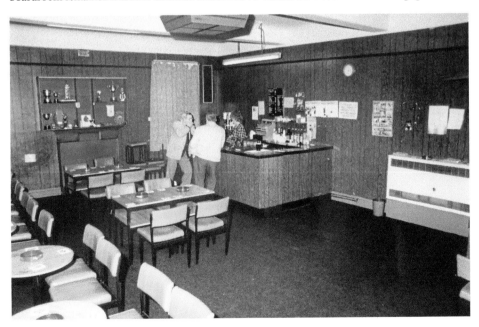

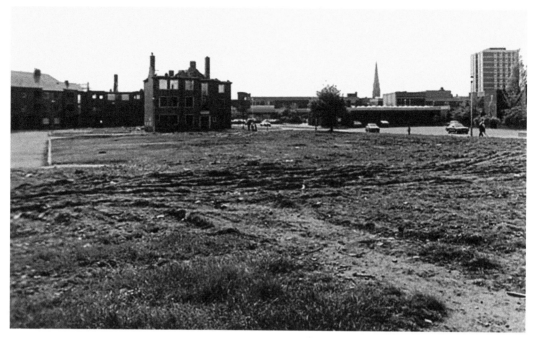

As part of the post-war regeneration programme, a complex of eighty-four dwellings were constructed to commemorate the Festival of Britain in 1952. Neglect and poor maintenance forced the demolition of the flats a mere thirty years later in 1982. The vast area they once covered lay barren for twenty years or more until it was converted into a car park. The two accompanying photographs from 1983 and 1999 show precisely how much land the housing complex covered.

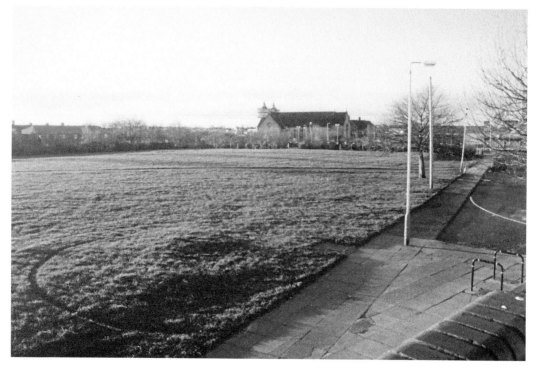

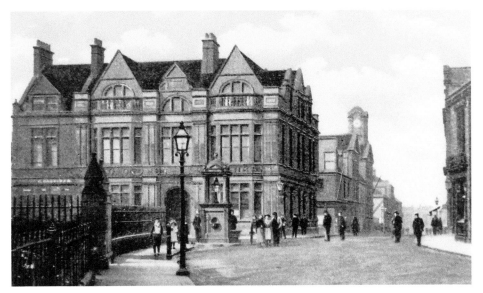

The Ben Lomond Hotel was by far the grandest of the town's public houses within the town centre. It is only in recent years the Victorian building ceased trading as a residential establishment. By 1970, and greatly in need of attention, the building was refurbished and renamed The Viking. In 1995, the grand old building had once again slipped into a state of disrepair. After a further restoration programme it was restored back to its original former glory, and reverted back to its original name, the Ben Lomond Hotel. This photograph dates from 1910.

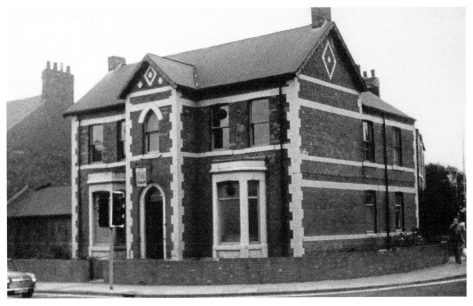

The original Alberta Social Club was situated in Albert Road, in the former residence of estate agent William Harris, who resided here until 1923. From then, it was owned by a physician who lived in the property until 1935, the same year the premises was converted into the club, and traded on the site until 1979. From then, a more modern establishment was purpose built on the site of a former bakery in Grant Street. The former club was demolished around 1980 for the construction of a block of flats, Kingfisher Lodge.

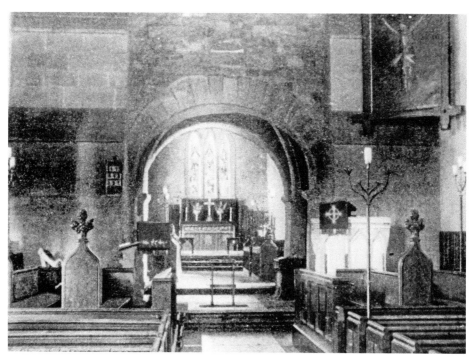

St Paul's Church, most of which dates from the seventh century, holds the distinction of being one of the country's oldest buildings. Evidence of this claim is in the form of two stones found in the church during restoration in 1782, which dedicated the church to St Paul. It has been claimed and disclaimed for many centuries, that Jarrow was the site of a Roman fort and settlement. This claim is supported by the discovery close by of two square pavements made from Roman brick and fashioned in the style of Roman masonry dating from AD 80.

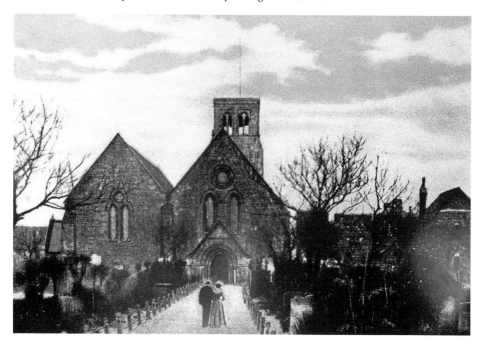

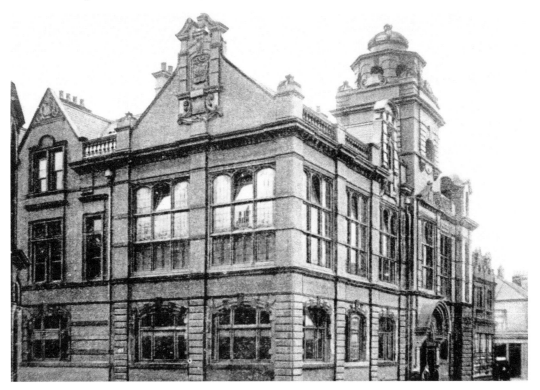

The 50th anniversary of the Jarrow Crusade in 1986 was celebrated with both triumph and tragedy. Triumph because the original 200 gallant crusaders completed the 250-mile trek against all the odds. Sadness because in 1986 the country was in a state of insecurity and depression reminiscent of those dark days of the 1930s, with in excess of 3 million people out of work. As a protest a further crusade to the capital was organised again with 200 able bodies, many of which were relatives of the original crusaders from 1936.

The formation of Jarrow Town Council was established many years prior to the construction of the town hall. The first municipal election of eighteen councillors for the recently created town wards was in 1875. The swearing-in ceremony and declarations took place at the Board of Health offices in Grange Road. Since the opening of the town hall in 1902, all major decisions concerning the town were made in the council chambers.

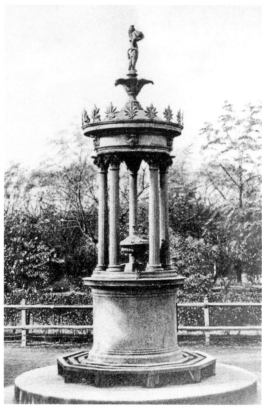

Sir Walter and Lady James bestowed many gifts upon the town, one of which was the West Park in 1876. Sir Walter's first association with the town was after his marriage to Sarah Caroline, daughter of Cuthbert Ellison, when he inherited the title of Lord Northbourne. The ornate drinking fountain at the entrance to the park was gifted by businessman and confectioner Alderman Thomas Sheldon in 1877. Among the parks many recreation facilities were tennis courts and bowling greens.

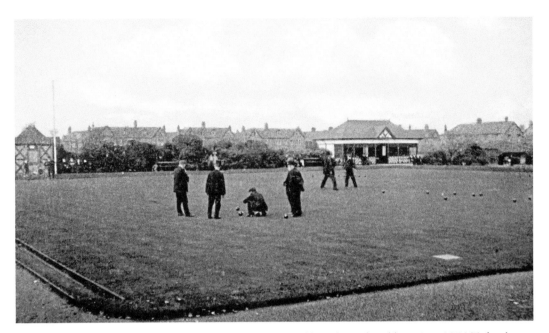

Competition bowls have been a feature of the town and have been played here since 1876. Today, league games are still played with the same enthusiasm during the summer months. In 1946, William Fyfe bowled himself into the record books with an amazing 360 games in one season. He was an enthusiastic member of three Jarrow clubs, and founder member of the Jarrow West End Club. This picture dates from 1921.

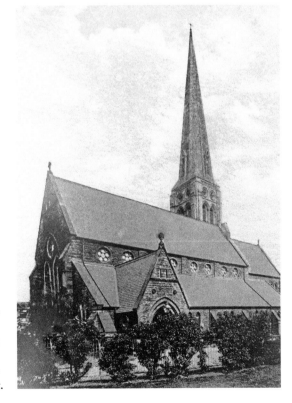

In 1863, and prior to the construction of Christ Church, evening services were held in schools. In 1868, Revd John Bee was appointed rector of the recently formed parish of Jarrow Grange. The following year, with the financial support of Sir Walter and Lady James, the church was built, and consecrated in October the same year. The tower and spire with six bells were constructed in 1882. On the occasion of the golden jubilee of the church in 1919 the Bishop of Durham dedicated two additional bells to make a full peal of eight.

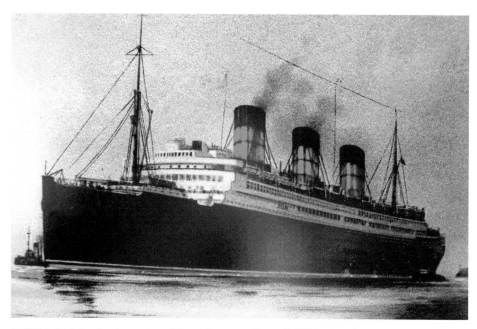

In 1936, Sir John Jarvis purchased from Germany Cunard's White Star Line RMS *Berengaria*. It was to provide work and wages for 1,500 unemployed men from Jarrow. Their task was to remove the superstructure as far as main deck level, as part of a ship breaking programme at the former Palmer yard. This scheme was initiated and devised by Jarvis in order to bring work to the town.

Monkton.

After the death of Bede in 735, the monastery suffered two devastating invasions, and from around this time it was left in ruins for centuries, quietly decaying. By 1083 the majority of monks at Jarrow had been relocated to Chester le Street. It is believed some of the monks fled to and remained in a cell at Monkton.

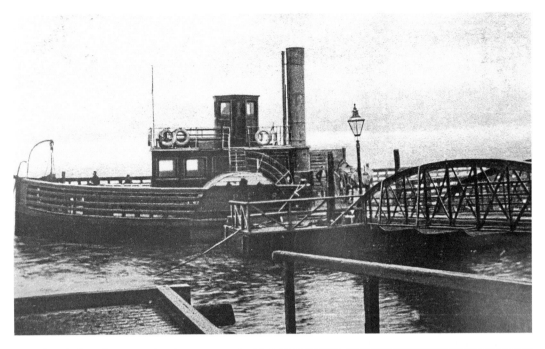

People have been crossing the Tyne to Howdon by any means available to them since the fifteenth century. A horse and cart ferry service between Jarrow and Howden began operating in 1883. The passenger and horse ferry *G. H. Dexter* was built by Palmers and joined the service in 1884. After almost forty years of service it was retired in 1923, and succeeded by *C. M. Palmer*, then *A. B. Gowan* I in 1921. *A. B. Gowan II* joined the fleet in 1935 and saw service until the demise of the ferry in 1967. In 1898, the service was transferred to the Tyne General Ferry Co. In 1919, it was transferred once again to the Jarrow Corporation.

CORPORATION OF JARROW
Jarrow and Howdon Ferries

Revised Tolls and Charges
(Approved by the Ministry of Transport under date 25th May, 1920)

CATEGORY	DESCRIPTION	FARE
PERSONS.	Passengers	0 1½
	Workmen's Weekly Passes (for 12 journeys only)	0 9
	Workmen's Dinner Passes	0 4½
	Extra Driver or Passenger (all vehicles)	0 1½
GOODS.	Goods under 1cwt	0 1½
	do 1 cwt. or over (per cwt.)	1½
ANIMALS.	Dog	0 1½
	Ox, Cow, or Neat Cattle, and driver	0 9
	Calf, Hog, Pig, Sheep or Lamb	0 1½
	Horse, Mule, or Ass (not Drawing) and Driver	0 6
VEHICLES.	Perambulator, Barrow or Chair, and 1 Person	0 3
	Cycle or Motor Cycle and 1 Person	0 3
	Motor Trailer or Side Car (extra)	0 3
	(2 wheels) Cart and 1 driver	0 7½
	(2 wheels) Trap and 1 driver	0 7½
	(4 wheels) Wagon or Brake, 1 driver and 1 horse 1	1½
	(4 wheels) Wagon or Brake, 1 driver and 2 horses	1 6
	(4 wheels) Wagon or Brake, 2 drivers and 3 horses	2 0
	Heavy Furniture Wagon, 1 driver and 1 horses	1 6
	Heavy Furniture Wagon, 2 drivers and 2 horses	1 9
	(4 wheels) Carriage or Wagonette, 1 driver and 1 horse	1 6
	(4 wheels) Carriage, 1 driver and 2 horses	1 1½
	Motor Car, (two seater) and 1 driver (passengers extra)	0 9
	Motor Car, (four seater) and 1 driver (passengers extra)	1 0
	Motor Wagon, (up to 2 tons) and 1 driver	1 6
	Steam or Heavy Motor Van (up to 5 tons) and 1 driver	2 6

There has been a reliable transport service in Jarrow since the construction of the railway station in Grant Street in 1872. In 1906, a tram service was introduced to transport men to and from work when Jarrow was a busy industrial town. The service was discontinued in 1929 in favour of the motorbus, and by 1940 the population was becoming dependant on public transport.

A bus depot owned by operators Northern General Transport was built to meet this demand in 1953. By the 1990s a depot of this size was deemed uneconomical as more commuters were now using the rapid Metro system. A smaller and more efficient depot was constructed close to the site of the original, which serves the town equally as well.

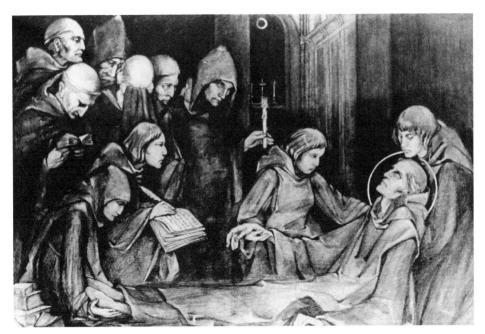

Jarrow's most celebrated resident Bede entered the Benedictine monastery aged twelve on the consecration of the abbey in 685 and remained there until his death from asthma in 735, aged sixty-two. He was a monk of great piety and knowledge, mastering everything that was known to man, earning himself the title 'The Father of English Learning'. He was buried in a porch made in his honour attached to the church where his bones rested for 287 years. In 1020, the monastery was visited by Ecgfrid Westoe, a monk from Durham and a notorious collector of saints bones, who stole Bede's remains and removed them to Durham Cathedral, burying them in the same coffin as St Cuthbert. Bede's relics remain at the cathedral in a tomb befitting a man of such great knowledge and wisdom, who gained respect throughout the civilised world.

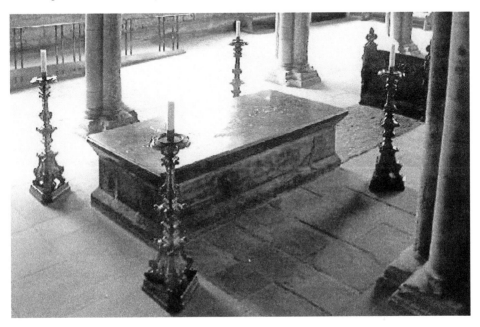

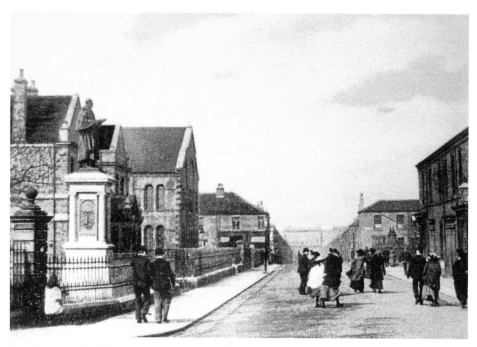

Another example of Palmer's generosity was the construction of a hospital in Clayton Street. The Palmer Memorial Hospital was erected in 1870 in memory of his first wife Jane. It was originally designed for the welfare of his workforce, who kindly subscribed to its upkeep. After the closure of the shipyard in 1934, the Board of Health presided over the day-to-day running of the Palmer hospital until 1947 and the introduction of the NHS. The ailing building was demolished during the '70s and replaced with a modern establishment, but still retaining the original name, Palmer Community Hospital.

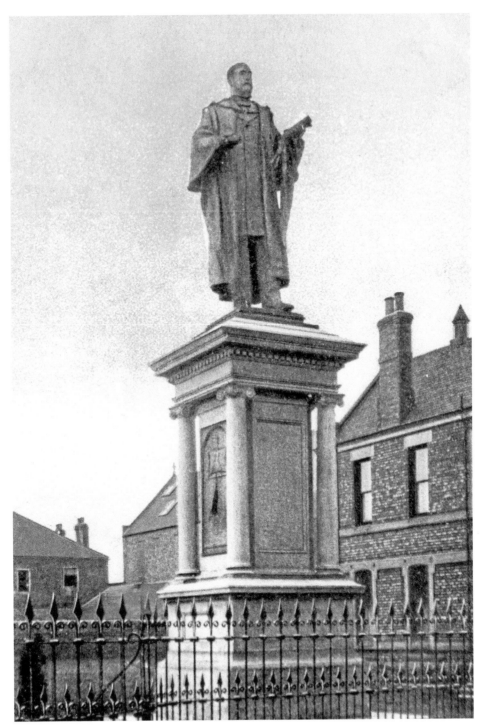

This bronze statue of Palmer by Albert Toft was erected by public subscription in 1904 within the grounds of the hospital. In 1972, the statue was relocated to a site overlooking the River Tyne. After several bouts of vandalism it was once again relocated in 2007 to a site opposite the town hall by the town's MP, Stephen Hepburn.

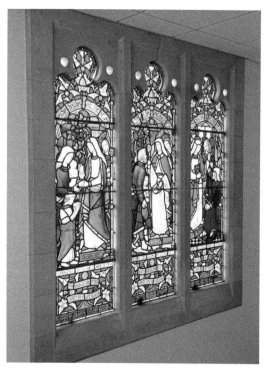

This fine example of a stained-glass window was at the entrance of the original Palmer hospital and depicts biblical scenes of charity involving women. It was funded and erected by the Palmer workforce in memory of his first wife Jane. It is now on display in the new hospital and remains a lasting memory to someone who did so much for the welfare of the town.

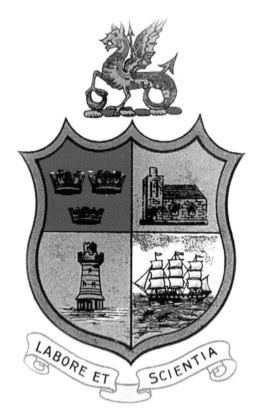

Although the motto remained the same, the original town's coat of arms bears little resemblance to the one we are more familiar with. It originates from 1875 when the borough of Jarrow was established. It depicts the town's association with shipbuilding, the Venerable Bede and a Roman occupation. In 1928, a more modern representation was approved that differed slightly. After the shape of the crest was simplified and registered in London the new insignia went on display in the town.

The town hall and council chambers were designed by South Shields architect Fred Rennoldson and officially opened in 1902. The clock, however, didn't appear until 1951, at a cost of £1000 paid for with the remainder of the Surrey fund. This £50,000 fund was donated by the people of Surrey for the welfare of the town during the dark days of the 1930s. As time passed, the clock began to behave erratically, and subsequently the movement was removed for service and refurbishment and now keeps perfect time.

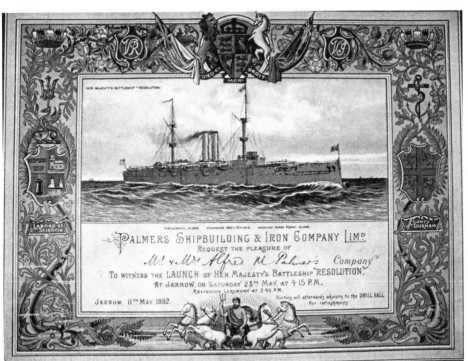

Throughout the world the ceremony of launching ships is deemed to be an auspicious occasion. Pictured is an invitation to such an occasion to the launch of battleship HMS *Resolution* from Palmers yard in 1892. The invitations usually invited the ship owners and their families, and were cordially extended to local dignitaries and members of the shipping fraternity.

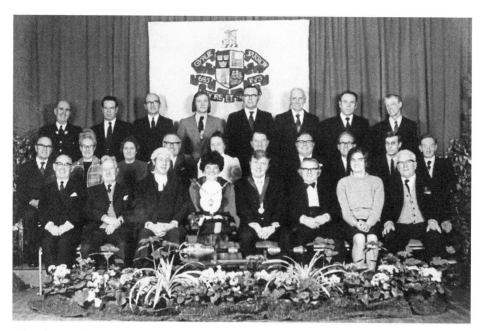

After the Local Government Act of 1858, Jarrow was created a municipal borough by charter, granted by HRH Queen Victoria in 1875. Pictured are the retiring council members and chief officers just prior to Jarrow Borough Council being disbanded, on the occasion of the town being amalgamated within the borough of South Tyneside in 1974. The first mayor of the town was Charles Mark Palmer, and the retiring mayor was Mrs Vera Davison, who is pictured in the mayoral robes.

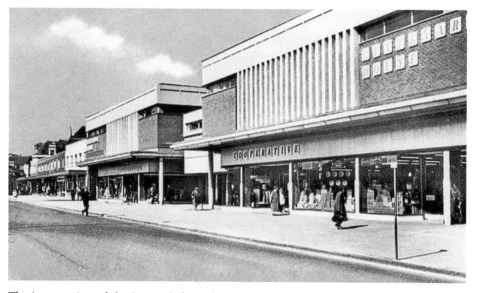

The inauguration of the Jarrow Industrial Co-operative Society was formed at a meeting of local businessmen in 1861 and valued at £21. The first retail outlet of the society opened in Commercial Road later the same year. The Market Square complex opened in 1863 as the Jarrow & Hebburn Co-operative Society and ceased trading 102 years later in 1965, when it was relocated to Centenary House in the Arndale Centre.

Prior to 1939, plans had been drawn up for a river crossing beneath the Tyne. In 1946, further plans had been drawn up for the construction of a total of three tunnels, the cost of which, £3.6 million, became prohibitive, and restricted to pedestrian and cyclist tunnels at a cost of £750,000. The outbreak of war postponed its initial construction until 1947. The completed tunnels were 300 feet in length and accessed by escalator and elevator, and opened in July 1951 by Minister of Transport, MP Alfred Barnes In May 2013, the sixty-two-year-old Grade II-listed complex was closed to the public for major repairs. The £4.5-million refurbishment was funded by Tyne & Wear Integrated Transport Authority. Pictured are the tunnel entrance and escalators.

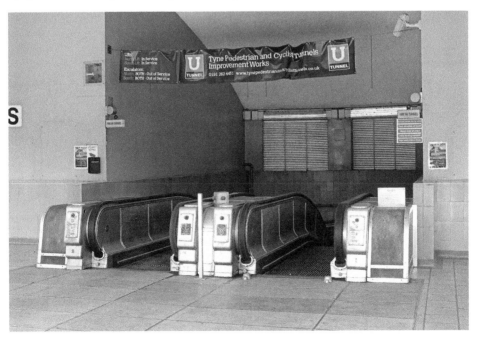

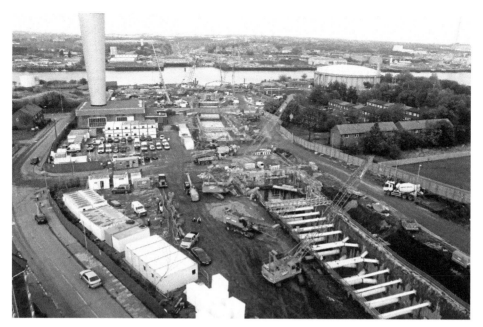

By 1961, work had commenced on the construction of a road tunnel, which was officially opened by HM Elizabeth II in 1967. The construction of a subsequent tunnel commenced in 2008, and completed in 2012 when Her Majesty returned to the area for its official opening. Pictured is the tunnel under construction in 2009.

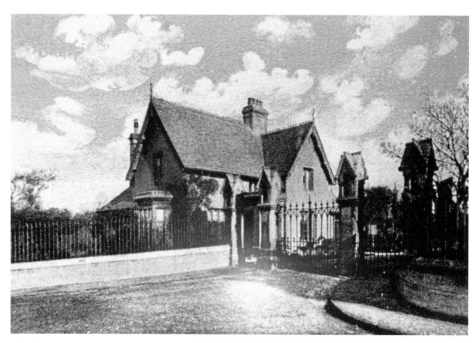

The first meeting of the Burial Board took place in September 1864, when seventy-seven applications were received by the board for the post of superintendent. Thomas Ramsay was chosen for the £63-per-annum position prior to the consecration of the 15-acre cemetery in 1869. For many years the cemetery has often been referred to as Ramsay's Garden. This image dates from 1900.

The creation of the 20-acre Monkton Dene Park provided work for 1,000 unemployed men in 1935, with each being entitled to one calendar month's work, with preference given to those with dependant families. Most men arrived for work with their feet poorly shod, preventing them from doing a satisfactory days work. Nine-hundred-and-ten pairs of quality work boots were supplied to carry out the work courtesy of the Surrey fund and organiser Sir John Jarvis.

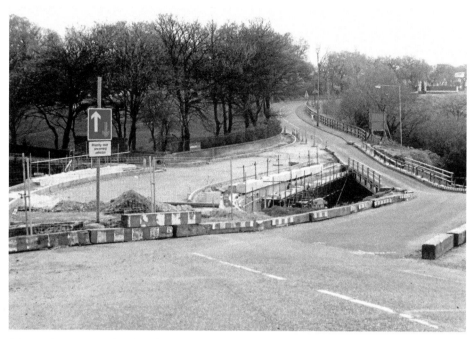

Prior to the creation of Hill Park Estate, the cemetery bank was used solely for its access. With an annual increase in traffic levels, and the introduction a bus service, the road surface had to cope with much more traffic than was intended. By the 1980s, a bridge spanning the River Don, at the foot of the bank, was showing severe signs of deterioration. Urgent remedial work was required to ensure the future of the ninety-five-year-old crossing. Just how much work was required is evident in the accompanying images.

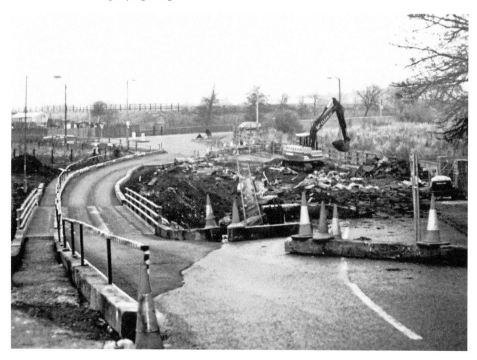

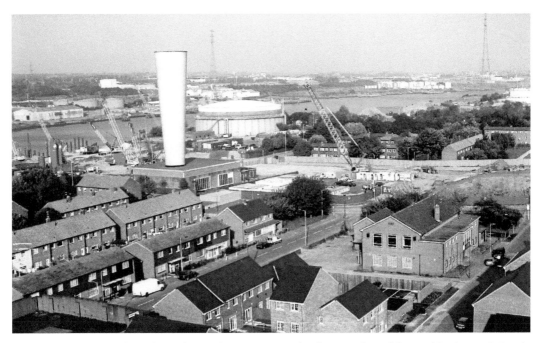

Aerial photography is the perfect medium to portray the changing face of the rural landscape. It is only from this pigeon's eye viewpoint we can realise just how much the town is changing. Compare this recent image to a similar view from the 1950s and the changes will become evident.

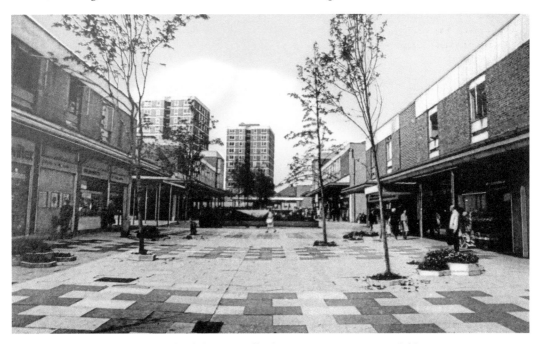

The Arndale Centre was divided into traffic-free precincts. In 1962, children's entertainer Harry Corbett and his famous glove puppets Sooty and Sweep were invited to officially open phase one of the complex. Phases two and three followed in 1963 and 1964. This image of a very smart Viking Precinct dates from 1963.

Actor John Savident, who played butcher Fred Elliott in *Coronation Street*, visited the centre during the '90s to coincide with a further refurbishment programme and change of ownership celebrations.

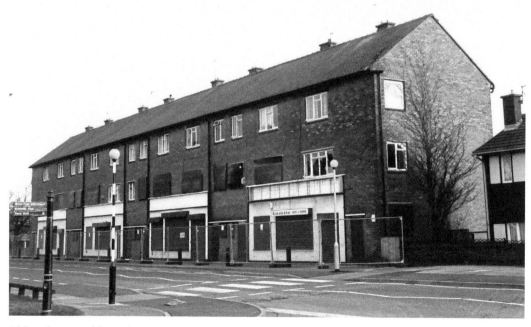

Although reasonably modern in appearance, this block of maisonettes dates from 1953. The boarded-up windows on the residences above the shops is evidence the properties were being vacated as early as the late nineties. The building was demolished in 2006, as the area was required for landscaping.

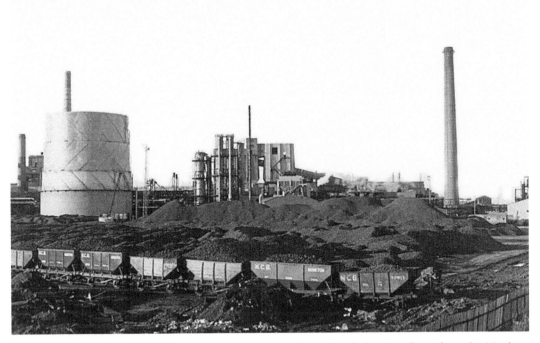

The Jarrow skyline was illuminated for many years by a fiercely burning flame from the Monkton Coke Works. Coke is a hard porous substance fuel derived from coal, which when ignited burns almost odourless without smoke and has few impurities, making it environmentally friendly. The flame was extinguished in 1990 at the closure of the plant.

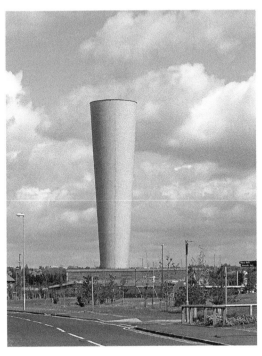

Around 1950, as the town was recovering from the effects of the war, the need for housing had never been greater. Modern new houses were beginning to appear almost overnight as the population regenerated. Now disused, the chimney-like structure in this relatively modern image was formerly a ventilator constructed in 1963 for the Tyne Tunnel. Today it is a listed building.

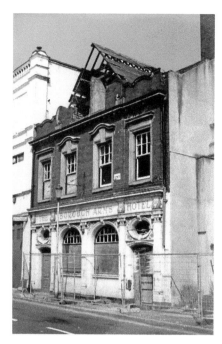

During the 1940s and '50s, Jarrow had no less than fifty-five public houses. As time marched on, some of these ageing buildings were showing signs of wear and tear and became unfit for purpose and subsequently demolished. This trend continued until 2000. This picture shows the Borough Arms in North Street during demolition in 1970.

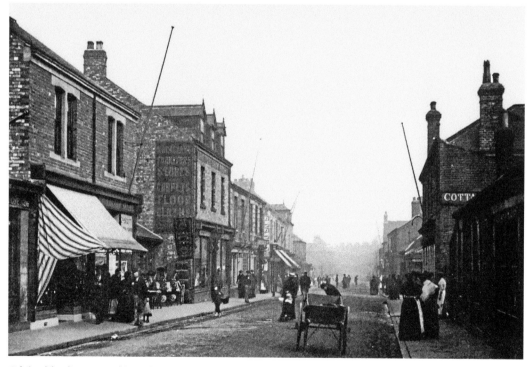

Of the fifty-five original hostelries only seven remain. One of the originals was The Cottage in Grange Road. This familiar watering hole had a monkey tethered to the inside of the window, which kept passing children entertained. It was reputed to have been left by a visiting seaman slightly worse for wear with the effects of alcohol during the 1940s when Jarrow was a busy seaport. It is just visible to the right of this image from 1906. Its namesake the Cottage in North Street was demolished in 2000.

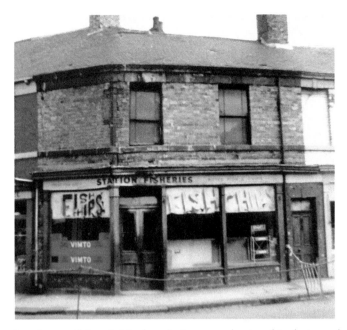

There were no less than ten fish and chip shops in Jarrow at the time this photograph was taken in 1959, when 'five bob' (25p) would purchase an armful of the delicacy, more than enough to feed a family of four. This was classed as a cheap and nourishing meal. An equivalent meal today for a family of four would cost in the region £25. This image is of Station Fisheries in Station Street.

Throughout its 1,000-year history, stained glass was used exclusively for the manufacture of windows for the adornment of churches, cathedrals and significant buildings of similar stature. These windows were painstakingly assembled by craftsmen from small pieces of coloured glass to produce patterns or pictures. This, reputed to be the earliest example of stained glass from the seventh century, forms a tiny window at St Paul's Church.

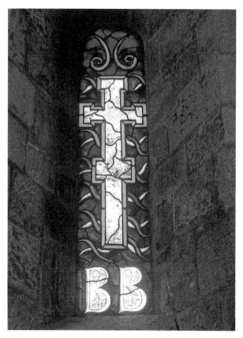

Another wonderful example of stained glass also at St Paul's, designed by artist John Piper. The window was a gift to the church by the Juno Trust and unveiled by HRH the late Diana, Princess of Wales, in 1985 to commemorate the 1300 anniversary of the dedication of the church. The window depicts the Jarrow Cross; the two capital 'B's represent Benedict Biscop who founded the monastery. Diana was one of the most celebrated consorts of the twentieth century, with her own distinctive and charismatic style.

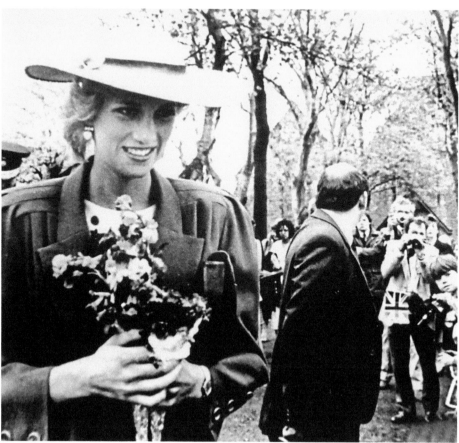

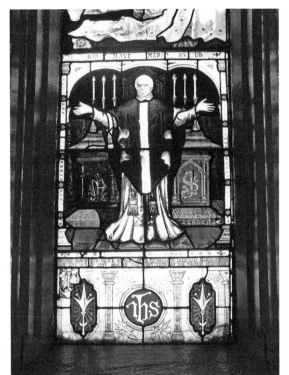

There are an abundance of leaded lights –
or stained-glass windows – in the town
centre, which are well worth seeking out.
One in particular is located at St Bede's
Church on the window overlooking Chapel
Road. It is a tribute to the church's founder
in 1861, Fr Edmund Joseph Kelly.

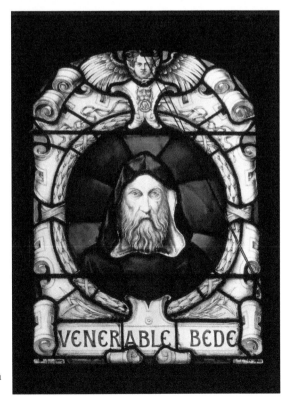

This magnificent stained-glass portrait
of the Venerable Bede is set in a window
within the council chambers at the town
hall, along with the northern saints, Aiden,
Hilda, Cuthbert and the founder of the
Jarrow monastery, Benedict Biscop. They
were gifted to the town from varying
benefactors at the inauguration of the town
hall in 1902.

Montague Burton, Lithuanian by birth, was born in 1885 and came to Britain in 1900. He was well educated but spoke little English. His first business in Chesterfield in 1903 was selling ready-made suits. By 1929, he had 400 shops and factories, specialising in the manufacture of made-to-measure suits and military uniforms. Though no longer a gentleman's outfitter, the Burton building in Ormonde Street currently supplies the town with fabrics.

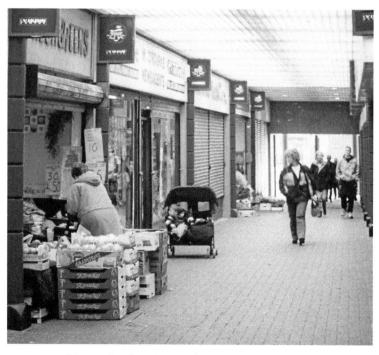

The two entrances to this popular shopping arcade were in Monkton Road and Viking Precinct. During the 1960s, Monkton Road was a thoroughfare for traffic and a busy bus route for journeys in and out of town. The arcade became a short cut for pedestrians to the precincts. In 1972, the road was closed to traffic and became partially pedestrianised.

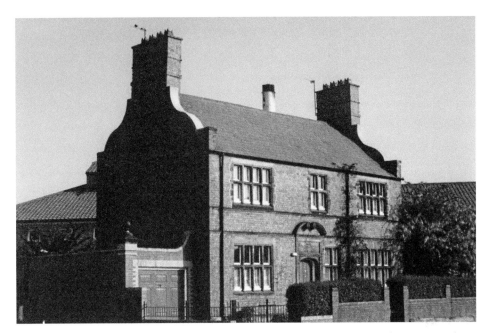

The Ecclesiastic Office of the Bishop of Jarrow commenced in 1906. Revd George Nickson held the position for eight years until the former Bishop of Sheffield succeeded him, holding the position until 1924. This late nineteenth-century house is reputed to have been the visiting bishop's residence. In later years it became the rectory attached to the parish of Christ Church. Today it is a private house.

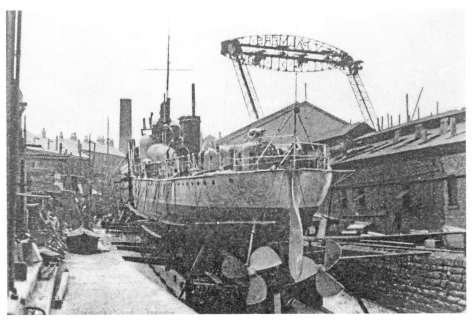

The Palmer empire reigned supreme for almost eighty years as a well-respected shipbuilding establishment the world over. Its abrupt closure in 1934 sent shockwaves around the town as 80 per cent of the town's working population became unemployed. The German-built overhead cranes, pictured here in 1912, dominated the Jarrow skyline for decades, and were demolished in 1938.

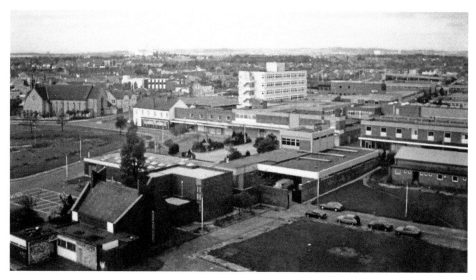

The white building in the centre of this 1980s image from Monastery Court was Arndale House, completed in 1962 and was generally given over to commerce. From 1965, the upper two floors of the four-storied building were used as a night club. Club Franchi was a partnership owned by a five-man consortium, Franchi and Valente. It was officially opened by the current Miss World Anne Sydney on 15 August 1965, and attracted international cabaret stars from the world of entertainment. Similar nightspots opened in subsequent years by the recently formed Baily Organisation. Club Franchi closed just four years later in 1969.

The Directors of Club Franchi
request the pleasure of the company of

Mr & Mrs. Di Paolo

at a

Cocktail Party and Cabaret

on the occasion of the opening at Tyneside's latest
and most fashionable night-spot to be held at

club franchi

Arndale House, Viking Precinct, Jarrow
on Sunday 15th August 1965

Reception RSVP
8 pm Arndale House, Viking Precinct, Jarrow

This Card must be produced at the Reception

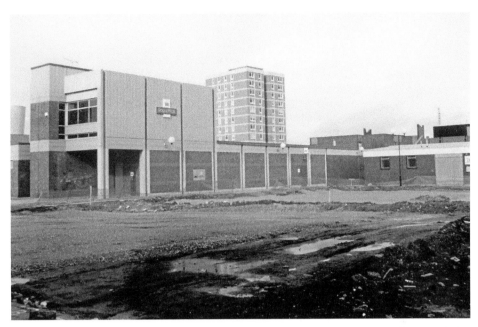

When the Arndale Centre was under construction during the 1950s, parking spaces for 200 vehicles were created, which were more than adequate at the time. By 1970, due to the increase in vehicular traffic, parking in the town centre was becoming a problem. The accompanying photograph clearly shows the creation of additional parking bays and modernisation of pedestrian walkways in Monkton Road.

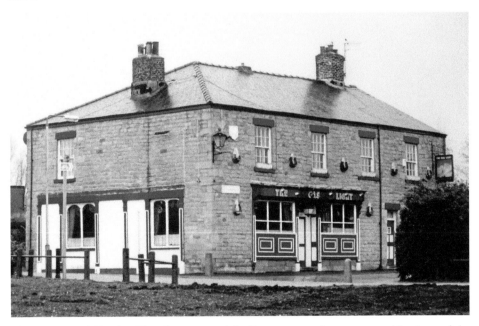

The Commercial Hotel in Tyne Street was originally a seventeenth-century coaching inn and the oldest public house in Jarrow. During the 1970s and because of its proximity to the Tyne Tunnel it changed its name to the Tunnel Tavern – another name change came along in the 1980s to the Gas Light. Pitman William Jobling is reputed to have been brought here after his execution in 1832.

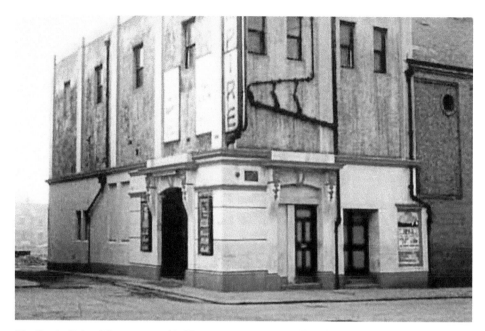

The Empire Palace Theatre opened in Union Street in 1912. As films for the big screen were becoming more popular it was renamed the Empire Picture Hall in 1925. Numbers of cinemagoers dropped dramatically during the 1960s and fell from popularity as television took hold. The building was converted into a bingo hall in 1969 until 1999, and was eventually demolished in 2004.

Local councillors, civic dignitaries and magistrates celebrated the opening of the police station and Court Buildings in Clervaux Terrace in 1930. Jarrow had previously been chosen as the ideal location for police cadet training for Durham County Constabulary. From 2010 all police business and court procedures were transferred to South Shields. The former Jarrow headquarters is currently used as a business centre.

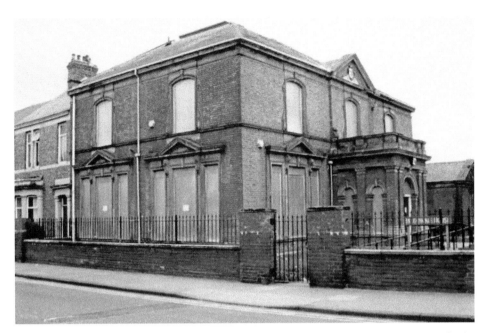

One of the town's finest historic buildings must surely be Balgownie in Bede Burn Road. The red-brick building was built as a private residence for surgeon Frederick O'Neil in 1875. Around 1900 the building was used as a dental surgery. From 1961 and after the closure of the Children's Welfare Clinic at the town hall it was transferred to Balgownie. From 1990 it became government offices until 2008. In 2017 the cherished building was undergoing renovation.

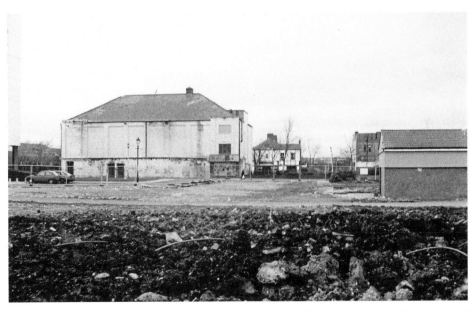

The area in this relatively recent photograph was once occupied by row upon row of tiny terraced Victorian cottages, which were demolished in 1957 as part of a regeneration scheme. This was to make way for modern accommodation in 1963 to meet the needs of the town council. A costly and uneconomical maintenance programme forced the demolition of the complex in 1985. It was replaced with a further complex of private dwellings.

Part of the Viking Centre was to be utilised for the construction of a purpose-built and much-needed supermarket. To make this possible, many buildings in the centre were demolished. The first of these was the four-storied Arndale House, which had been clad in decorative blue glass panels in 1980. When the facia was removed it exposed the original building from 1962.

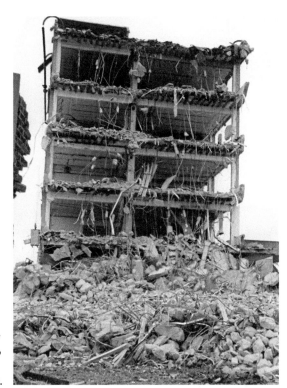

Many of the original shops were demolished when the contractors moved in. The majority of Monkton Road disappeared within a week, along with one side of the Viking Arcade. Forty-year-old buildings, which were formerly occupied by a tenpin bowling centre and later the Presto supermarket, were in a very short space of time reduced to a small mountain of rubble.

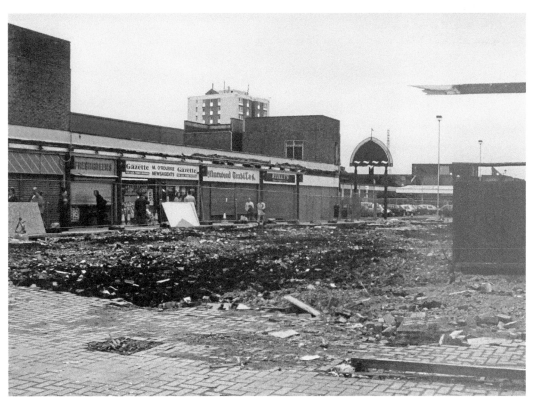

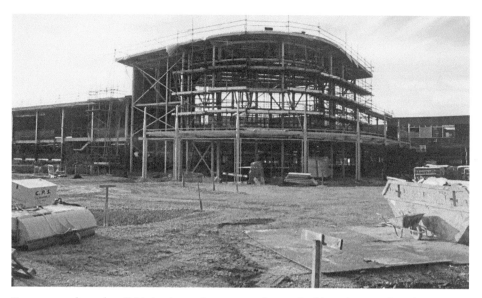

Every square foot of available land was given over to the new build, to the cost of small businesses and the dismay and annoyance of many of the shopkeepers, who were given the opportunity to relocate to other parts of the centre. No sooner did the old buildings disappear, the framework for the new supermarket appeared.

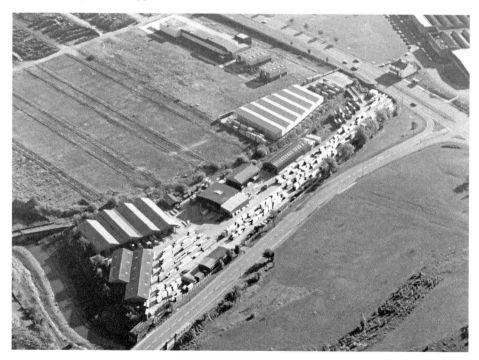

East Jarrow, as it was referred to, was distanced from the main body of the town, but still under the jurisdiction of the town council. It was self-sufficient, having enough industry to give the small population employment. Eventually the industries and township disappeared. From around 1940, the area was peppered with sawmills and timber merchants. This aerial photograph of Southern's timber yard dates from the 1970s.

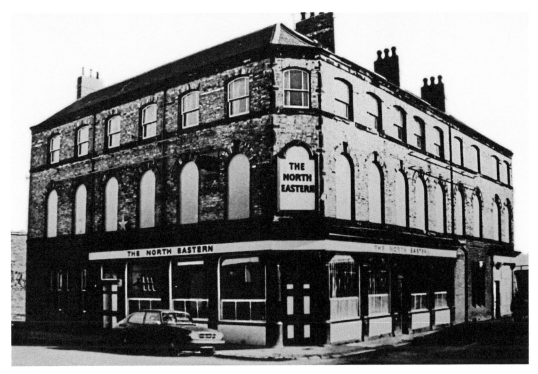

The North Eastern Hotel in Station Street was built by Palmer to accommodate hospital personnel and visiting dignitaries. The twenty-bedroomed establishment ceased trading as a residential hotel from 1968. From this time it traded solely as a public house, until its demolition in the 1980s.

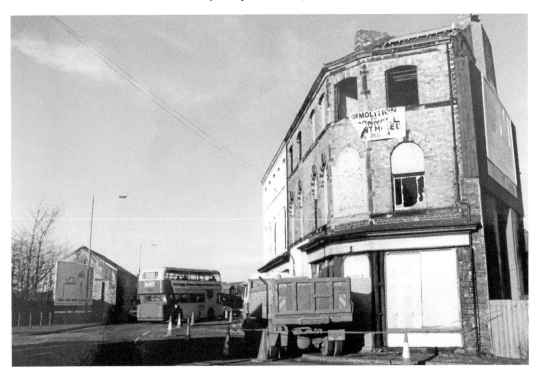

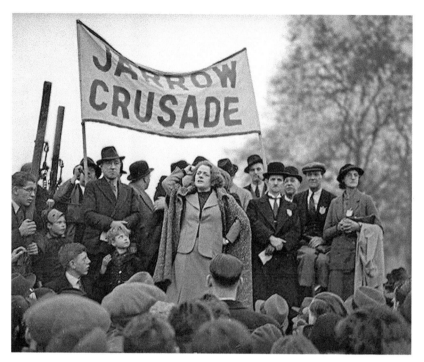

Member of Parliament for Jarrow Ellen Wilkinson and 'Crusade' delegates pictured addressing a rally at the start of the 'Jarrow Crusade' on 5 October 1936. Ellen came to Jarrow from her constituency in Middlesbrough in 1935 to take up the position after the retirement of former MP Robert Wilson. In 1945, she was elected Minister of Education. She fought tirelessly for the people of the 'Town That Was Murdered'. She was one of the principal organisers of the crusade to the capital along with Labour Party stalwarts David Riley and Joe Symonds.

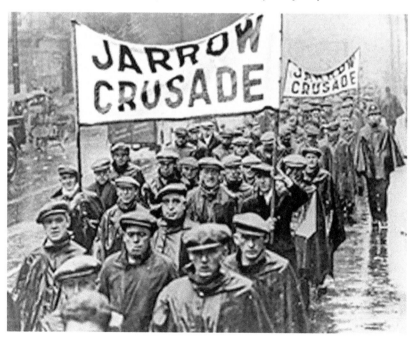

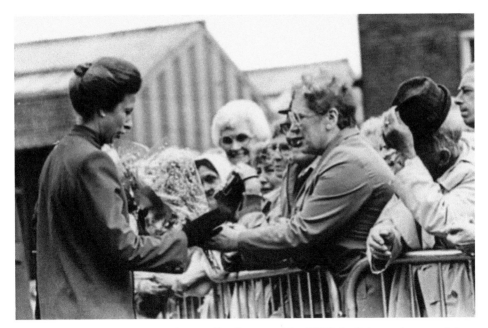

The Palmer Community Hospital was officially opened by HRH the Princess Anne on 5 June 1987. She is pictured here with members of the community. The plaque commemorating the occasion is on display at the hospital.

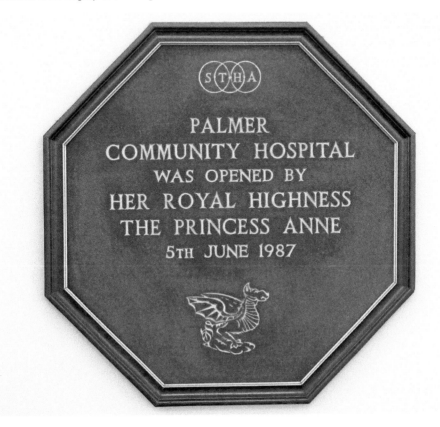

PALMER
COMMUNITY HOSPITAL
WAS OPENED BY
HER ROYAL HIGHNESS
THE PRINCESS ANNE
5TH JUNE 1987

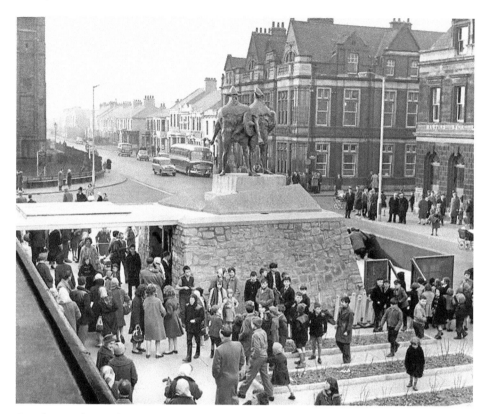

A sculpture of two Viking warriors by Colin Davidson was presented to the borough of Jarrow by S. H. Chippendale on behalf of the Arndale Property Trust, unveiled in Grange Road by Her Worship the Mayor Councillor Violet Hope on 17 February 1962. The sculpture commemorates two Viking invasions to our shores in AD 794 and again in 866. They were received with mixed feelings when they first appeared, but are now part of the fabric and history of the town. Pictured are dispersing crowds after the unveiling of the sculpture, and again in 1963.

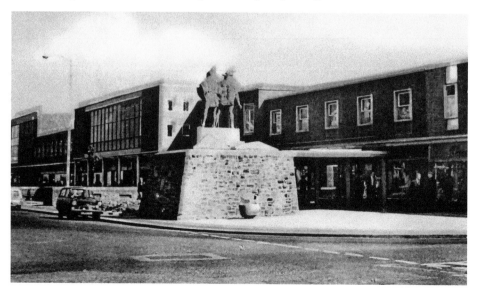

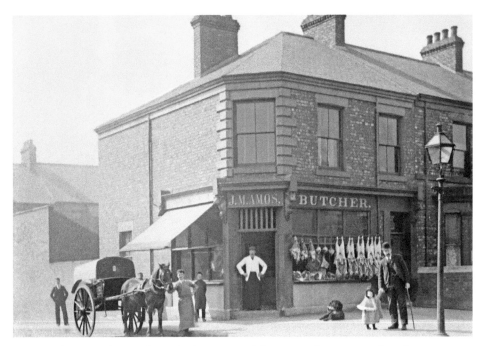

Eating habits were far simpler at the beginning of the twentieth century, at least for carnivores. Virtually every part of the animal was used in one way or another. Pig's trotters, cow heel, heart, tripe, kidney and liver were all for sale in butchers shops, and were part of the daily diet. These ingredients were essential for wholesome nutritious family meals. This hand-tinted image of Amos's butchers in Albert Road dates from 1906.

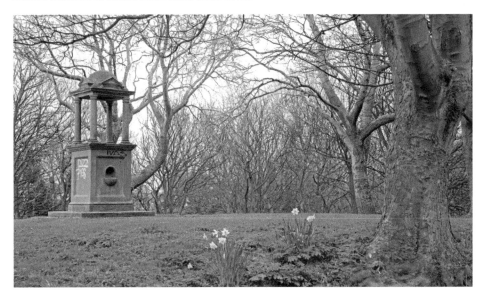

The Longmore Memorial Fountain was unveiled on 17 February 1891 by Lady Carlisle at the junction of Grange Road and Ellison Street. Forty-nine-year-old Joseph Longmore, who died in 1890, was a Methodist preacher and Trustee of the Wesleyan Chapel. He was president of the temperance society Band of Hope. The fountain in the accompanying photograph was relocated to its present position at Springwell Park in 1921.

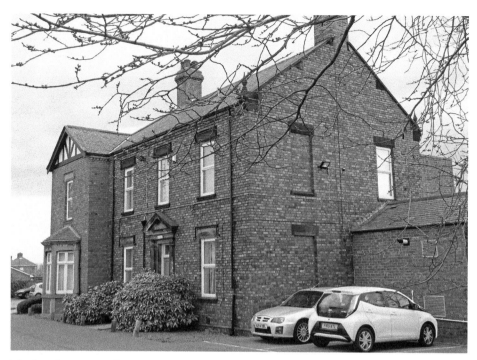

The foundation stone for a hospital specialising in the treatment of infectious diseases was laid by the Mayoress Mrs Salter in September 1886. The £3,200 building was erected on a two acre site at Primrose. The site was chosen as the air was thought to be cleaner than the air surrounding the town centre, therefore assisting recovery. The building today forms part of the NHS.

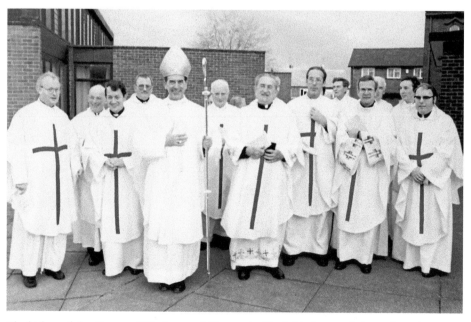

The bishop of the diocese of Hexham and Newcastle, Hugh Lindsay, and clergy from the region after concelebrated mass on the occasion of the silver jubilee and consecration of St Matthews Roman Catholic Church, York Avenue, in the town on 21 November 1983.

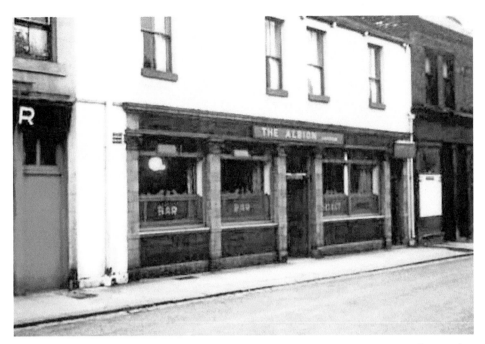

One of the seven surviving public houses is the former Albion in Walter Street. Similar to other hostelries in the town, it changed its name. From the early 1970s it became The Jarrow Crusaders. A further name change came along in 2014, McConnells Gin & Ale House.

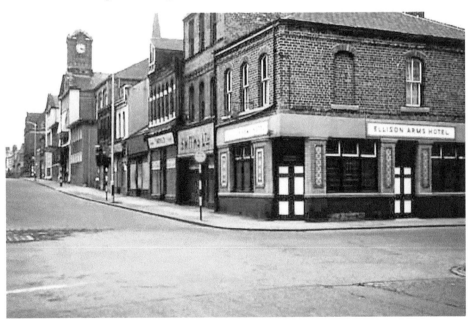

Pictured here in 1956 is the junction of Ellison Street and Western Road. To the left of the photograph is the Mechanics Institute built by Palmer as reading and recreation rooms in 1864. The clock and tower were gifted to the town by Lady Northbourne. During the 1950s the council took over the day-to-day running of the building, renaming it the Civic Hall. Today, it is used as a gymnasium and restaurant.

While the majority of Grant Street was residential, the area to the right of the station stairs was taken up with lock-up garages, and occupied by builders and plumbers. The area was demolished in the '70s, and the site today forms part of the Metro system. This photograph dates from 1960.

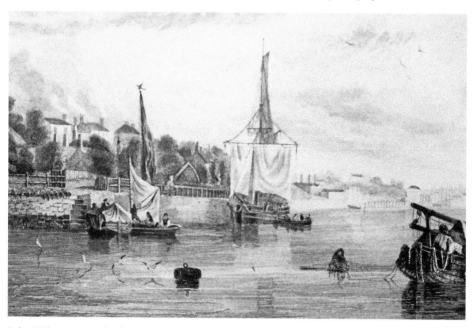

John Wilson Carmichael was a prolific artist specialising in marine scenes. Born in Newcastle in 1800, he worked from a studio in London and various locations around the country. In 1829, he painted this picture of Simon Temple's slipway at Dunkirk Place. A mosaic replica of the painting was gifted to the town in 1904 by Drewett Ormonde Drewett, and is on display in the former council chambers at the town hall.

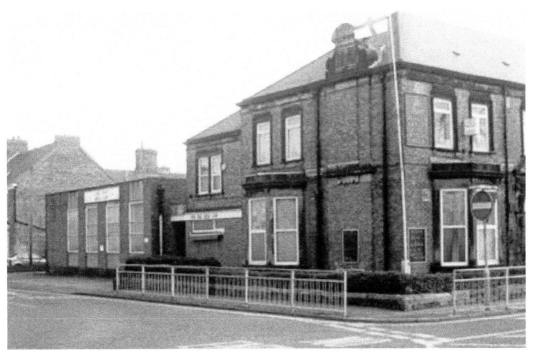

The Parliamentary seat for Jarrow was created during the Redistribution of the Seats Act of 1885. Since then, the last Liberal to serve the seat lost in the 1922 election. The last Conservative to hold the seat was former Mayor William George Pearson in 1931. From 1935 to 1947 the seat was served by Labour stalwart Ellen Wilkinson, and has been served since by politicians representing the Labour Party. Pictured are the Labour Party Headquarters in Park Road.

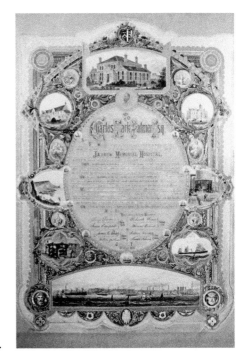

This charter was presented to Charles Mark Palmer on the occasion of the opening of the hospital, in 1870, he built in memory of his late wife Jane. The illuminated charter was a gift from his workforce, who held him in high esteem and also contributed generously to the welfare and upkeep of the hospital.

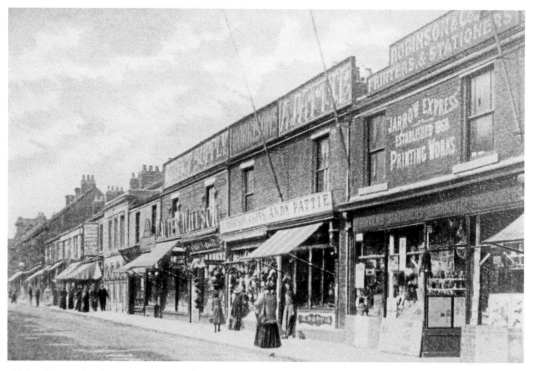

Of the three main shopping streets in the town centre, Ormonde Street was perhaps the most popular. The *Jarrow Express*, the town's newspaper, is advertised, and was printed here at Robinsons printworks. The broadsheet was published weekly until 1913. This hand-tinted picture postcard of Ormonde Street dates from 1904.

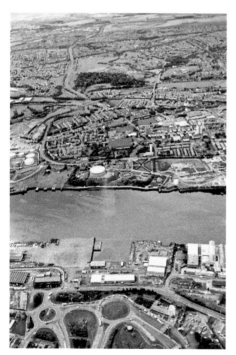

During the eighteenth and nineteenth centuries the River Tyne was answering to the demands of industry for the import and export of produce. Chemical works, coal mining, salt winning and a variety of other industries were springing up on either side of this industrious river, who were seeking means of transport for their produce, and conveying raw materials to these industries. This resulted in the Tyne being improved by dredging and widening to accommodate the unpredictable river traffic.

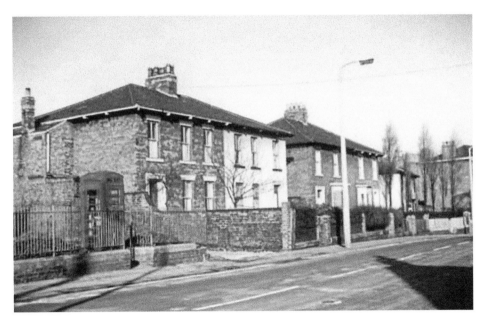

As the popularity of the cellular phone in the 1980s gathered speed, the public were becoming less dependent on public telephones. The Post Office introduced the red kiosks that had been a familiar sight on our streets since 1926 and were a necessity for those of us who didn't enjoy the luxury of a private line. As the mobile phone gained popularity, the need for the iconic 'red box' became most unfashionable, and eventually disappeared from our streets. The terraced houses in this elegant Victorian thoroughfare, St John's Terrace, were occupied by medical practitioners and doubled as their private residences and surgeries. The properties were demolished during the 1960s; however, some of the semi-detached properties on the opposite side of the terrace survive today. The two accompanying images date from 1959.

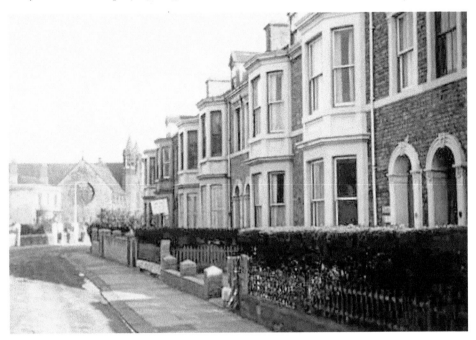

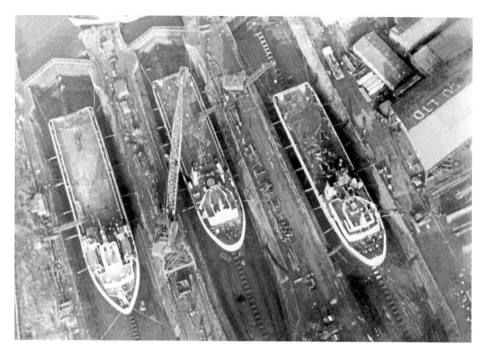

As the Palmer success story continued, Gavin Smith recognised the need for a yard specialising in ship repair close to the mouth of the lucrative waters of the River Tyne. The Mercantile Dry Dock Co. was founded in 1887, and by 1908 was operating three dry docks. All classes of ship repair were undertaken on hull, engine and boiler, along with comprehensive welding and electrical work. A fourth dry dock was completed in 1960, along with a deep water quay, both of which were capable of accommodating vessels up to 24,000 tons. Several changes of ownership followed; finally Court Line took over the yards operations in 1977, until its demise in 1981.

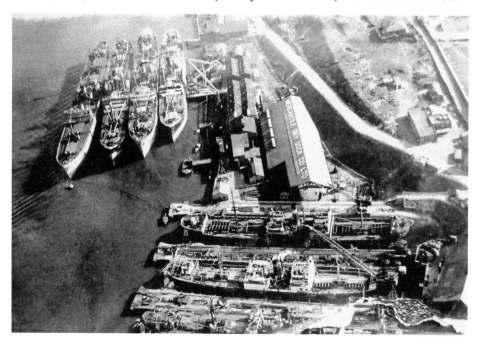

The Bede Industrial Estate opened for business in 1948; it was welcomed and looked upon favourably as part of the town's post-war recovery. Many global companies were attracted to the site and its modern factories. Part of this attraction was its proximity to the River Tyne, which enabled easy importation of raw materials for manufacturing and the exportation of what they produced. This aerial photograph from 1947 shows the extent of the partially completed estate.

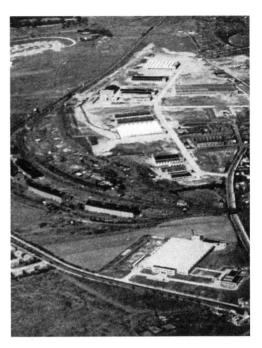

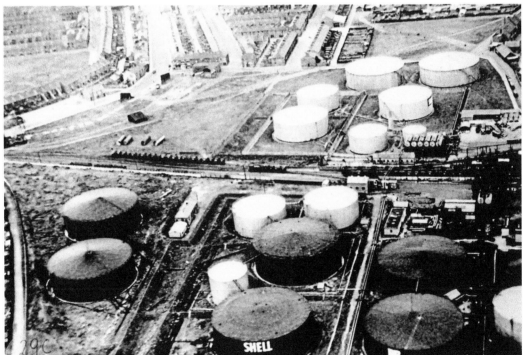

The Shell Mex & BP Oil installation plant situated close to the river at Quay Corner was one of the biggest and busiest in the country, capable of storing up to 5 million gallons of petroleum and fuel oil. Regular deliveries of the precious and volatile cargo were made direct from the wells in the Middle East, by sea, to the storage facility via the River Tyne. Further deliveries were made by a rail link that terminated within the complex, visible in the accompanying aerial photograph from 1950.

Cigarette Components Ltd was an American company and a subsidiary of Bunzl Pulp & Paper Ltd, world leader in the manufacture of filters for cigarettes, started production in a single unit at the Bede Industrial Estate in 1949. By 1958 they were operating a further five factories on the site in order to keep pace with the demand for their products. Morganite Resistors supported the Bede Industrial Estate for many successful years, and was a principal supplier of fixed and variable resistors to the government, radio and electronics industry. Paton & Baldwin's established a new plant at Jarrow manufacturing knitting yarns from natural and man-made fibres for several years, employing over 400 staff. Though much of the work was for women, it nevertheless became a vital and worthwhile asset to the town's ongoing recovery.

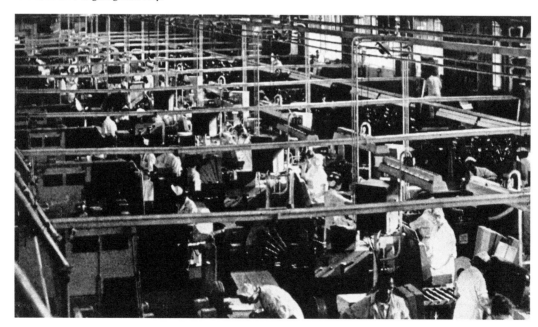

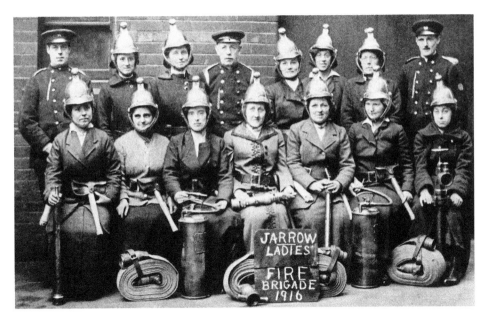

Prior to 1939, Jarrow boasted a comprehensive fire service and, similar to others in the country, was taken over by the government during the war years. The Jarrow Brigade was divided into two sections for both men and women, and was situated in Wylam Street, but in later years was transferred to the former Civil Defence unit in Bede Burn Road. In 1948, Durham County Council took over the Jarrow division and amalgamated with the Hebburn Brigade at their Hedgeley Road headquarters. The ladies fire service from 1916 is pictured.

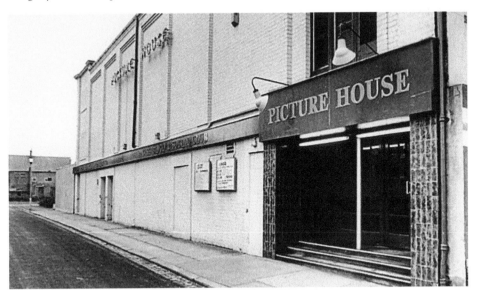

The leading form of general entertainment in Jarrow during the early years of the twentieth century was provided by the town's three cinemas: Empire, Regal and the oldest of the three, the Picture House. It was built on the site of a former cinema, the Gem, but demolished following a severe fire. Other forms of entertainment, such as billiards, were available along with dancing at the Mechanics Institute and the Billiard Hall, both of which were in Ellison Street. The cinema was demolished during the 1990s.

In 1948, the population of the town was 27,500 and the number of habitable properties in the borough was close to 12,000, which includes the 400 properties under construction at Simonside and Bilton Hall. The proposed layout for a housing estate to the south of Leam Lane with a further 950 homes, two schools and an assortment of shops was due for completion by 1955. This estate was to relieve congestion and rehouse 3,500 people from dilapidated properties within the town centre. The cost of renting these properties in 1955 was set at 5s 3d (26p) per week. Poor quality housing at Albion Street in 1930 and South Leam Estate in 1957 is pictured.

Wealthy industrialist, ship and colliery owner Simon Temple was born in South Shields in 1759. He opened the Alfred Pit in 1803, close to his shipyard for the convenience of the transportation of the coal. In 1785, he built Jarrow Hall as his private residence on a recently acquired substantial estate, which included St Paul's Church. Because of his lavish lifestyle, carefree spending and his failing business empire, a looming bankruptcy order hanging over him eventually led to his inevitable downfall. He died aged sixty-three, penniless and in poverty at the home of one of his former butlers in 1822.

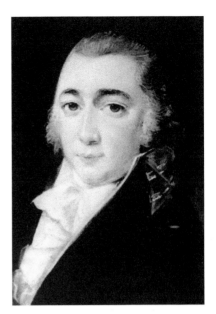

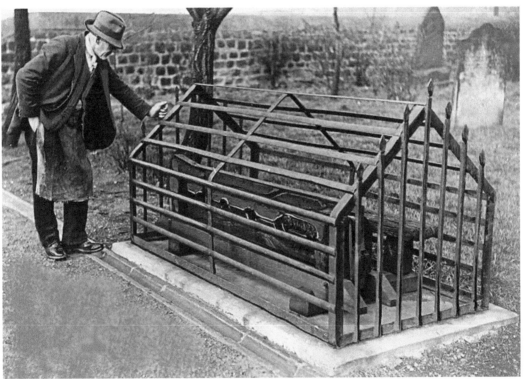

The tower and chancel at St Paul's Church was founded in AD 681 prior to the arrival of the Bede. The basilica was built later in the decade and were two separate structures. The nave of the church and the north aisle were constructed in 1866 under the supervision of distinguished architect Sir Gilbert Scott. The thirteenth-century stocks, pictured here in 1931, were used regularly for punishment. Damaged beyond repair by centuries of the savage northern weather, the remains of the stocks were removed around 1960 to Durham Cathedral.

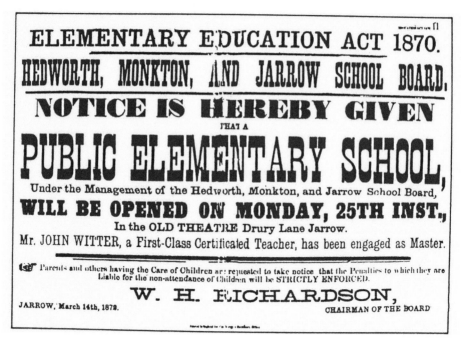

Members of the country's first school board were elected on 24 March 1871, when former paper mill owner William Richardson was sworn in as chairman of the Hedworth Monkton and Jarrow School Board. Pictured is a public notice advertising the occasion of the town's first school, under the Elementary Education Act of 1870.

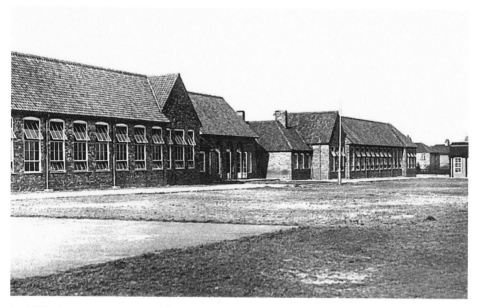

In 1945, there were seventeen schools in Jarrow under the jurisdiction of the 1944 Education Act. By 1950 this responsibility was entrusted to Durham County Council, who provided school meals, a health service and recreational facilities. The council were also working towards the promise of greater opportunities for schoolchildren. This photograph of Valley View School at Primrose dates from 1939.

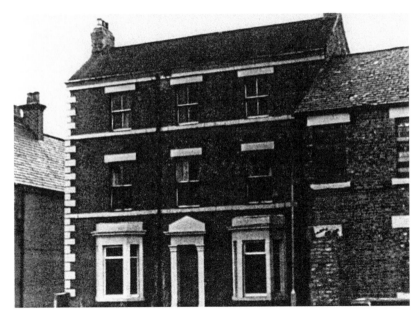

A parish centre was established in 1907. The church believed men and boys of the parish should have social and recreational facilities. The site chosen for the Parish Men's Club was a disused former temperance hotel occupied by the Marist brothers in Chapel Road, adjacent to the church. The boys section was to occupy the two top floors of the building and supervised by two committee members. After the Second World War, the boys club was relocated to Acca House in Grant Street; the Chapel Road premises were converted into licensed premises in 1947, St Bede's Parochial Men's Club. Pictured is the club in 1960.

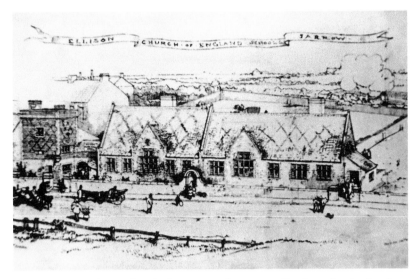

In August 1871, Sir Walter and Lady James agreed to an application of a site for the purpose of building a school, which was to be the first of its kind built in the north of England under the recently formed Elementary Education Act, and accommodated 1,000 pupils. It was opened in November 1872. This was followed by Bede Burn School in 1873, St Peter's in 1874, Ellison School II in 1882 and Croft Terrace in 1895. Pictured is a drawing of the first Ellison C of E School in 1863.

A chain of office is worn by the mayor, and the mace is usually carried preceding him are symbols of legal authority and civic dignity. The mace was originally a weapon of defence and carried into battle by medieval bishops rather than the sword, eventually becoming a ceremonial symbol. This silver and ebony mace was presented to the Mayor Councillor Patrick Scullion by the town's industrialists in 1949.

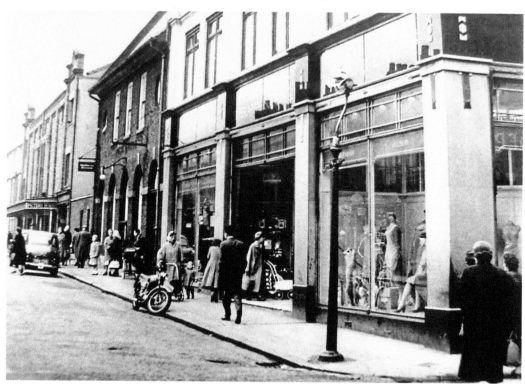

The position of letter carrier for the post office in Ellison Street was given to Hannah Fairley in 1858, who held the trusted position until her retirement from the postal service in 1879. In September the following year, the Mayoress Mrs Duffell laid the foundation stone for a principal post office, pictured here in North Street. After a life span of eighty-eight years it moved to a state-of-the-art sorting office with a counter service in Monkton Road in 1972.

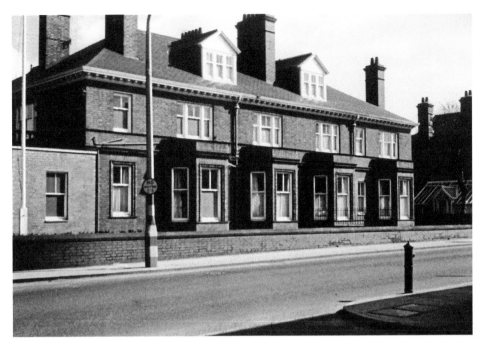

Housed in a purpose-built Edwardian building in Bede Burn Road, the Danesfield Maternity Hospital opened in 1941. It was for a short time manned by volunteers until 1948. From then it was under the care of the Regional Hospital Board until 1974. The Regional Health Authority then took over until its closure in 1982. It was replaced with a thirteen-bedroom residential home for patients with learning and physical difficulties.

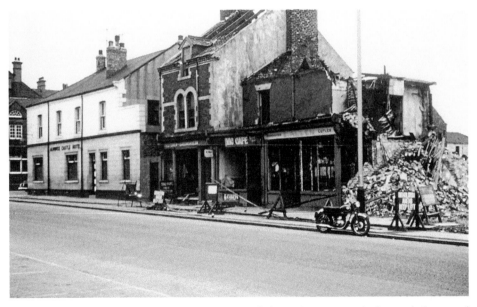

As the construction of the Arndale Centre progressed, the ageing property in Ormonde Street and Grange Road were slowly disappearing. This photograph taken in Grange Road illustrates the work in progress. The public house to the left of this 1955 image was the Alnwick Castle Hotel, which was demolished in the early 1960s.

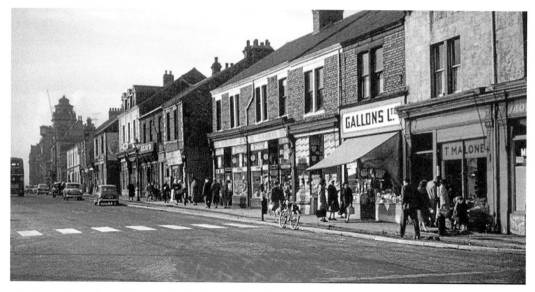

The demolition of the old properties in Grange Road and Monkton Road commenced around 1956, with Monkton Road taking priority. The shops in Grange Road and Ormonde Street were among the last to go. None of the businesses in these three streets transferred to the precincts. The photograph shows Grange Road 1960.

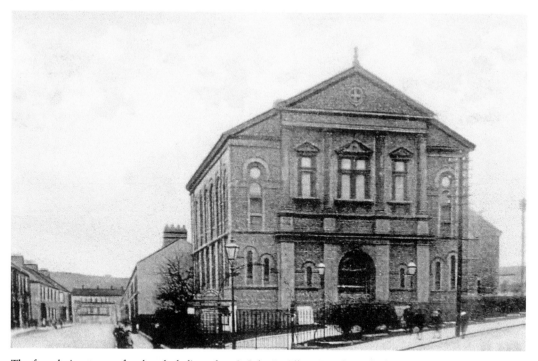

The foundation stone of a church dedicated to St John in Albert Road was laid in 1870. The 800-seat church for the Wesleyan community was consecrated and ready for use by June 1872. The church was built on the site of a former school from 1860. The school offered private education for those who could afford the fees, and formed the basis of the Kings School at Tynemouth. It was relocated to its present site at Tynemouth in 1865.

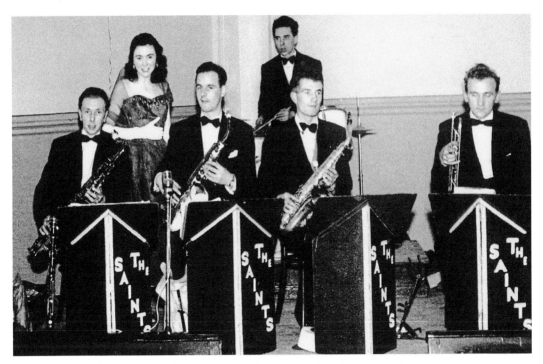

Dance bands were extremely popular not only in Jarrow but throughout the country, as it was among the leading pastimes during the 1940s and '50s. One of the most successful of these bands in Jarrow and Hebburn was the Saints, which had its origins in St Kildas' church hall in Ellison Street. Many musicians appeared alongside one of the founder members, band leader and trumpeter Ed McConville, pianist Alan Bully, percussionist John Graham and on clarinet and alto sax Phil McNally. At the height of the dance band era in 1949, the Saints played nightly across the region.

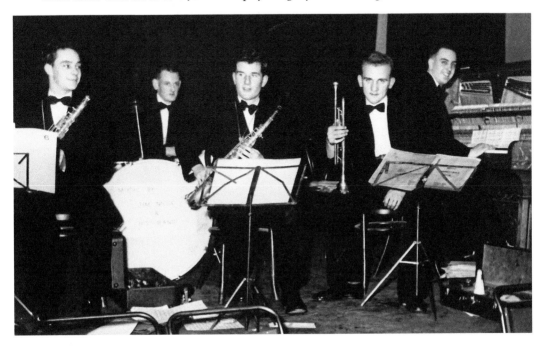

Children failing to pass the eleven plus examination generally left school at fifteen. As the 1950s dawned, the employment situation had changed dramatically: no longer did men stand around street corners with nothing to do. There was work and plenty of it, enough for everyone to get their fair share. Former mayor and youth employment officer Councillor Sam Rowan offered guidance to youths preparing to leave school and assistance in choosing a career. Pictured is the Youth Employment Office in Grange Road West in 1959.

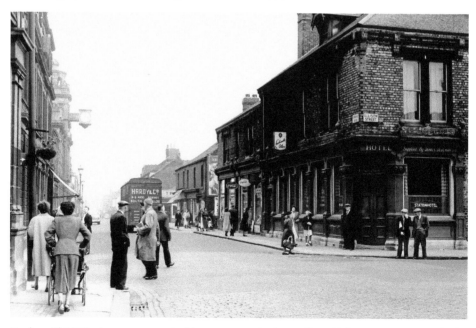

By the mid-1950s there was a marked improvement in the quality of life in Jarrow. People had a better standard of living to what they had been used to a few short years ago. Houses with electric light and hot running water had suddenly become a reality and were a vast improvement from the row upon row of dilapidated Victorian houses with outside toilets, which were disappearing almost as fast as they were being vacated. Pictured is Grange Road in 1956.

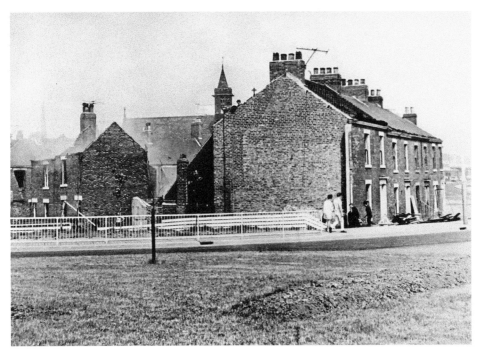

This terrace of two-up two-down houses in Monkton Terrace were eventually demolished by 1960, and replaced with approach roads for the forthcoming Tyne Tunnel. The image dates from 1959.

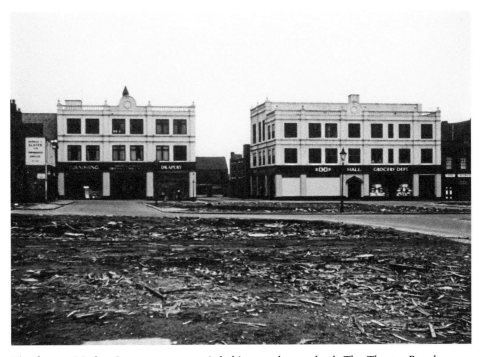

The former Market Square once occupied this now barren land. The Theatre Royal was a prominent building on the open land directly in front of the Co-op. Built in 1850, It was demolished just prior to when this image was taken in 1963.

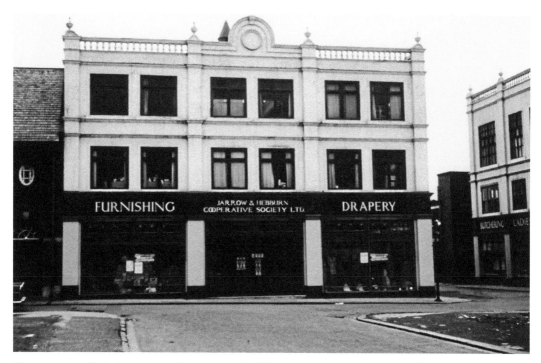

These two not dissimilar images of the Jarrow & Hebburn Co-op in North Street illustrate precisely how many different departments can be housed within two buildings and the services offered by the society. Built in 1892 at a cost of £8,500, it was devastated by fire seven years later in 1899 and rebuilt. Five years after this photograph was taken in 1960, the various departments were contained under one roof at Centenary House in Ellison Street. The building to the left eventually became the Cavalier Club.

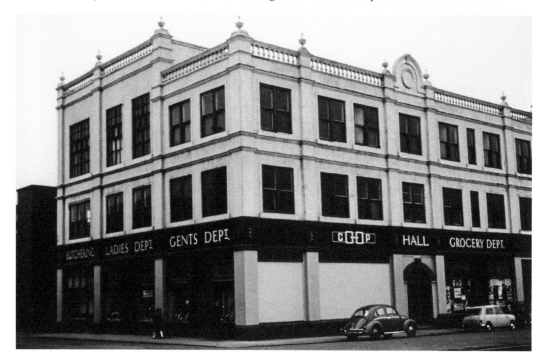

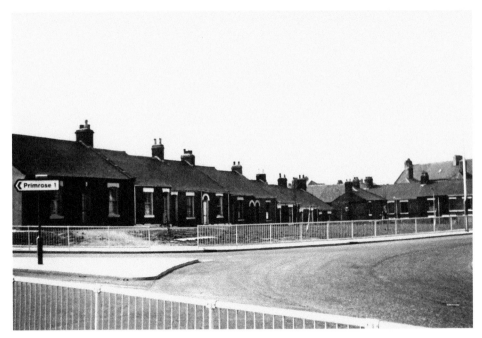

This terrace of cottages in Edward Street was demolished during the 1960s as part of the reclamation programme, and replaced with modern-style housing on the Wuppertal Estate during the '70s.

The Pontop & Jarrow Railway was designed by George Stephenson in 1826 and saw service in the coal industry from 1855, carrying coal from the Durham coalfield to the Tyne at Jarrow. In 1932, this prosperous line was purchased by colliery owners and renamed Bowes Railway, after the major shareholders Bowes Lyon family. From 1947 the line was owned by National Coal Board and by 1974 much of it was disused, with the exception of 3.5 miles from Monkton to Jarrow staithes. The line finally closed in 1986. Pictured is the Albert Road crossing.

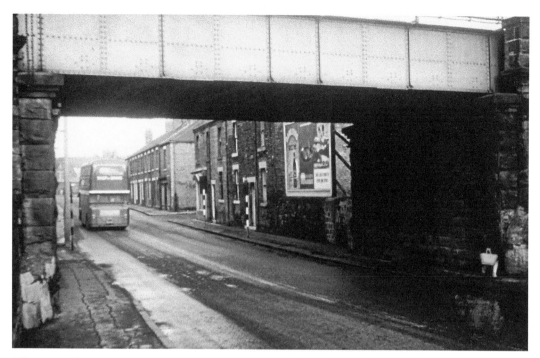

Albert Road looking in a northerly direction. This photograph was taken from beneath the railway bridge in 1969.

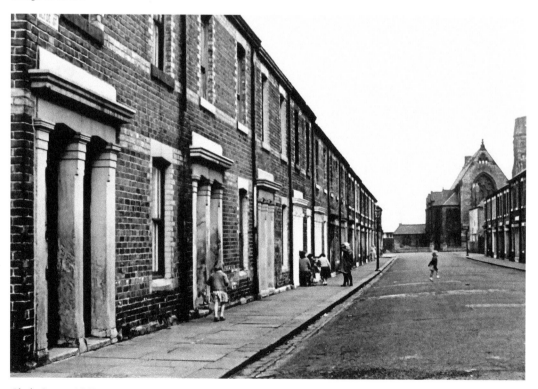

Clyde Street, 1962.

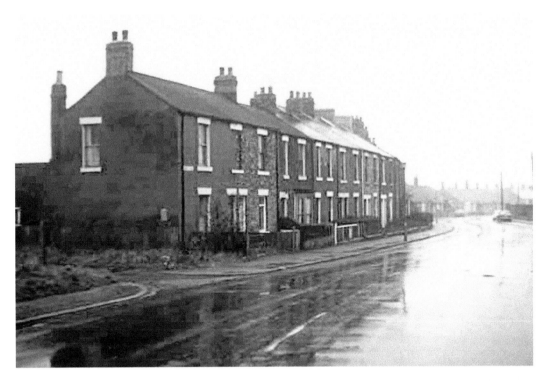

These notices of compulsory purchase were usually issued prior to any action being taken by the issuing authority, giving them the power to acquire rights over an estate in English land law to purchase an estate outright without the owner's consent, but in return for compensation. They were legal and binding notices that enabled all interested parties to air any grievances they may have. Pictured here, in 1969, is the property in Wood Terrace to which the notice refers.

THE HOUSING ACT, 1957

BOROUGH OF JARROW
WOOD TERRACE (CLEARANCE AREA)
COMPULSORY PURCHASE ORDER, 1969

WHEREAS the Council of the Borough of Jarrow have submitted to the Minister of Housing and Local Government for confirmation, the above-named Order which would authorise them to acquire compulsorily for the purposes of Part III of the Housing Act, 1957, relating to Clearance Areas, the land included in the Order.

NOTICE IS HEREBY GIVEN that a Public Local Inquiry into this matter will be held by R. H. Heath, Esq., A.R.I.C.S., A.M.T.P.I., Dip.T.P., at the Council Chamber, Town Hall, Jarrow, on Tuesday, 15th December, 1970, commencing at 10 a.m.

A copy of the Order and of the map referred to therein are on deposit at the Town Clerk's Office, Town Hall, Jarrow, and may be seen there, on application, at all reasonable hours.

E. R. BRUNNING

AUTHORISED BY THE MINISTER OF HOUSING AND LOCAL GOVERNMENT TO SIGN IN THAT BEHALF.

19th OCTOBER, 1970.

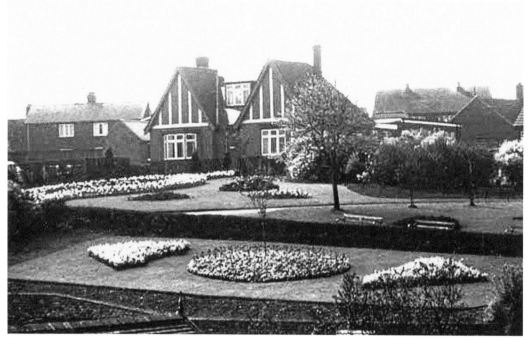

The beautifully manicured lawns and flower beds of the park keeper's cottage at Jarvis Park in 1956. The property is now privately owned.

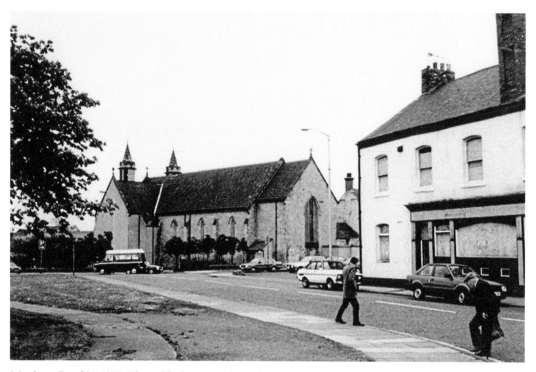

Monkton Road in 1970. The public house to the right was the Queens Head, which was built in 1872 and demolished in 1986. St Bede's Church to the left was built in 1861.

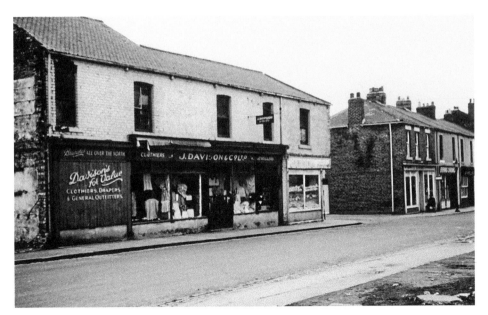

The practice of pawnbroking was recorded as far back as the ancient Greeks and Roman Empire. The Chinese also practiced it some 3,000 years ago in a similar fashion as we know today. For a time the church allowed Franciscan monks to pawn their goods in order to help the poor. Pawn shops had arrived in England by 1340. Though not quite as far back as that, this picture of Davison's pawn shop in Walter Street dates from 1960.

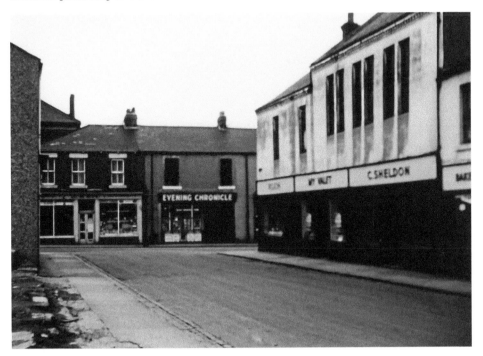

This image from 1955 is of North Street. The premises visible, horizontally, to it were in Walter Street and occupied by Rea's ice cream parlour, and the offices of the local evening newspaper, the Newcastle-based *Evening Chronicle*, who had branch offices in most towns in north-east England.

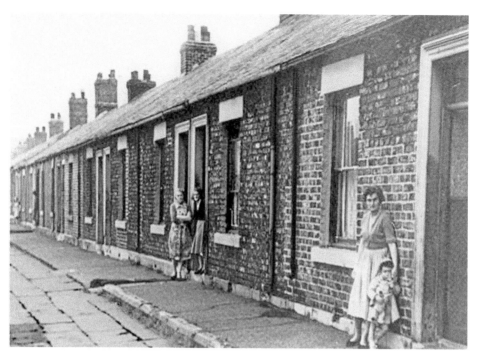

Cottages in Hibernian Road together along with those in Caledonian Road and Charles Street were demolished in 1955 in preparation for the Arndale Centre. This photograph dates from 1942.

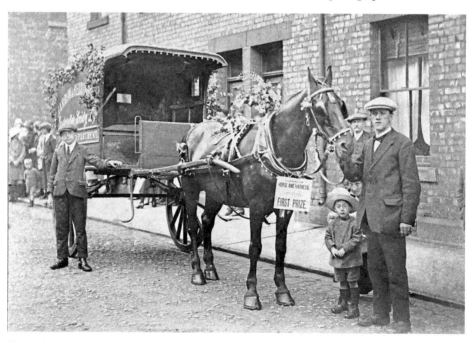

Horse-drawn carts and handbarrows were a common site down our streets nationwide with traders usually making door-to-door deliveries and purveying their wares up until as late as 1960. Pictured at the J&H Co-op depot in Wilberforce Street are winners of the annual Horse & Harness competition in 1921.

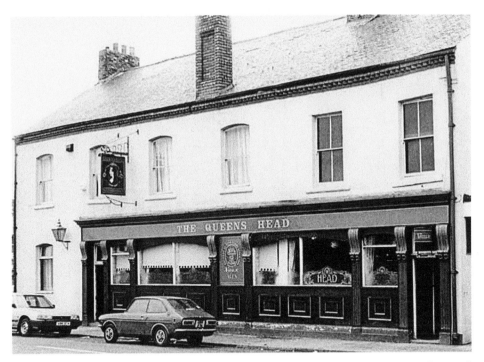

Two of the town's oldest public houses, the Queens Head in Monkton Road and Rolling Mill in Western Road, both of which were tied houses, to Vaux Breweries and Scottish & Newcastle Breweries respectively. Both of these buildings, similar to most of the watering holes in the town, were demolished during the 1980s.

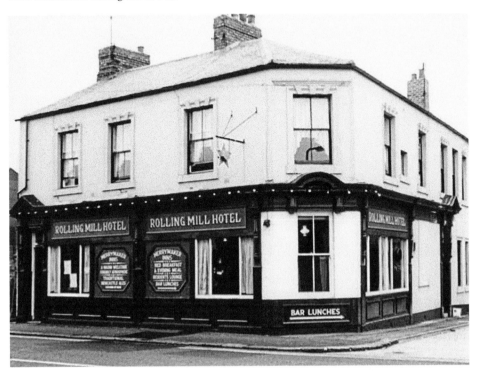

Up until 1963 the registrar's office, which dealt with local births, deaths and marriages, was situated in Ellison Street. From then it was located at Back Suffolk Street until 2001. It now forms part of the borough of South Tyneside with offices in South Shields.

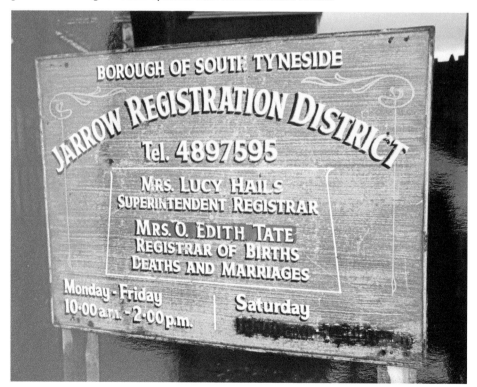

After lying uninhabited and neglected for some considerable years, Simon Temples' residence, Jarrow Hall, lay uninhabited and in a state of dereliction. The Corporation utilised the decaying building for storage from 1935 until 1974, when it was converted into the Bede Monastery Museum. Financing was courtesy St Paul's Development Trust and various local charitable organisations. Today, the museum is known as Bede's World.

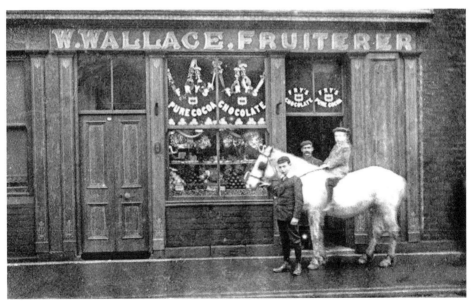

Fruit and vegetable shops were plentiful throughout the town around 1900; however, the merchandise available was somewhat basic by today's standards. Exotic fruit and vegetables grown in warmer climes did not appear on the shelves of British retailers until well after the Second World War. Today, fruit, vegetables, herbs and spices from around the world are readily available almost everywhere. Pictured is Wallace's fruit shop, Clayton Street, in 1902.

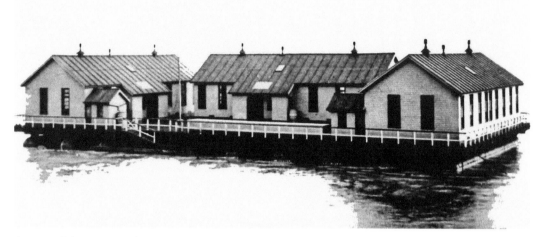

As part of their ongoing health regime in 1880, the port of Tyne Health Authority commissioned the construction of a floating quarantine hospital. In 1884, it was moored into position at Jarrow Slake. This quarantine hospital, which specialised in the treatment of contagious diseases from abroad, became a valuable asset to Jarrow when Tyneside played a vital role in the movement of freight from the River Tyne. River traffic arriving from foreign parts was requested to fly a yellow flag signifying contagious disease could be aboard.

Park Road at the junction of Albert Road, 1954.

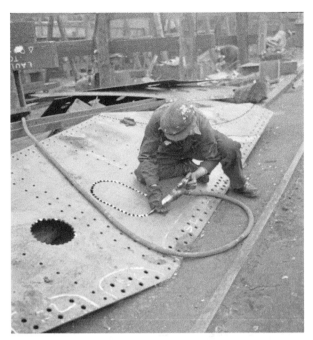

Caulker burner, Palmer's works, 1928.

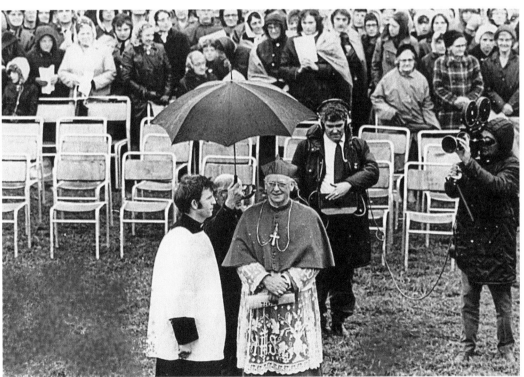

Despite persistent and torrential rain, 15,000 pilgrims from all parts of the north-east gathered at Belsfield School football ground to celebrate the 1,300th anniversary of the birth of the town's patron saint, the Venerable Bede, in May 1973. Mass was concelebrated by Monsignor Cardinal John Heenan as principal celebrant, assisted by a further twenty priests from the diocese.

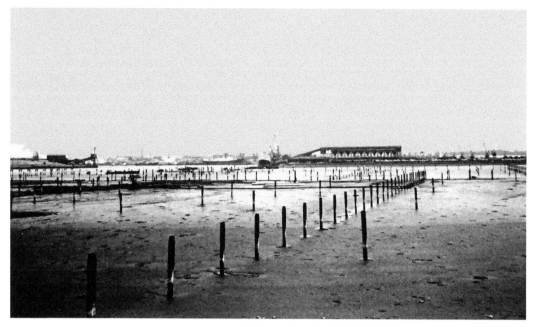

Jarrow Slake – or Jarra' Slacks as it has become known and long since corrupted from its geographical name 'Jarrow's Lake' – was, during Saxon times, an expanse of water covering some 470 acres. In those far-off days it was seen as an important estuary, important enough for Ecgfrid, King of Northumbria, to use as his principal port in which to anchor his fleet. Records reveal this site was formerly occupied by a Roman station. This claim has been argued and challenged by historians for centuries; however, it was eventually chosen by Benedict Biscop to build his Benedictine monastery on the deserted site in AD 680. Centuries later, the 'slake' was used for preserving timber. The accompanying images show what the area was like in 1950.

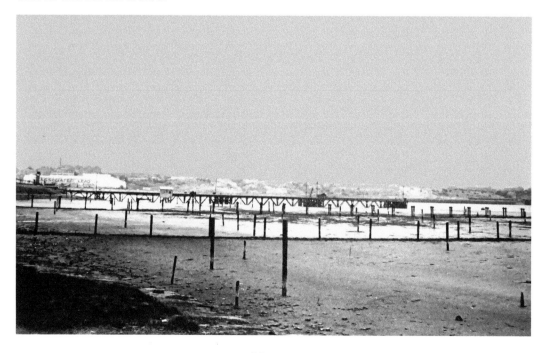

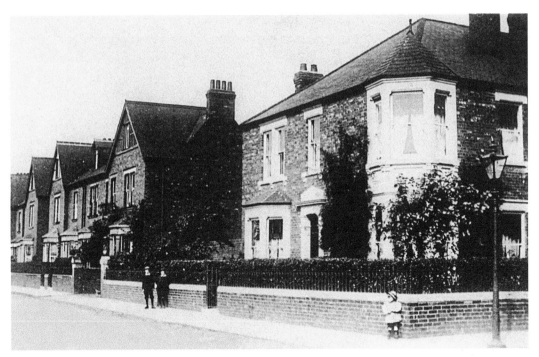

The house to the right of this 1906 photograph of South View was the Labour Party Headquarters up until 1973. From then all party business was transacted in larger premises close by in Park Road.

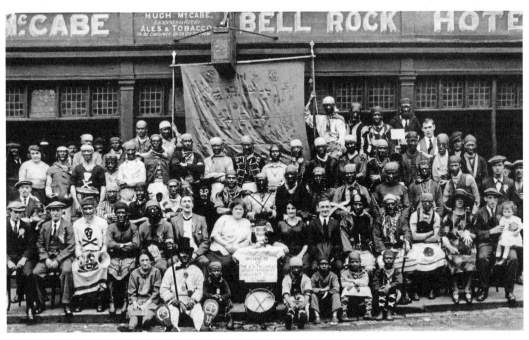

Management, locals and their families celebrate at the Bell Rock Inn at Nixon Street as their football team won the covetous Ingham Infirmary Challenge Cup in 1923. The celebrations lasted until the small hours as manager Hugh McCabe put on a lavish carnival-style street party to celebrate the team's victory.

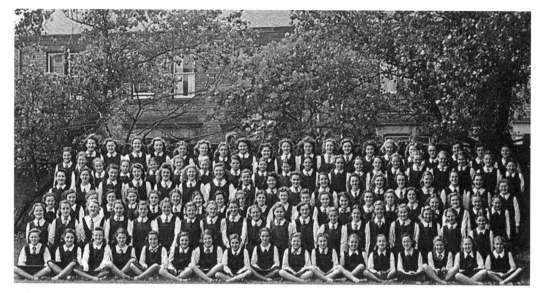

Belsfield School ceased being a facility for girls in 1959, when St Joseph's Comprehensive School at Hebburn became available the same year. The school then became St Bede's Secondary Modern Senior School for Boys, who were transferred to the Bede Burn Road School in 1960 from Harold Street to conclude their formal education. This photograph of the girls was taken in the grounds of the school in 1947.

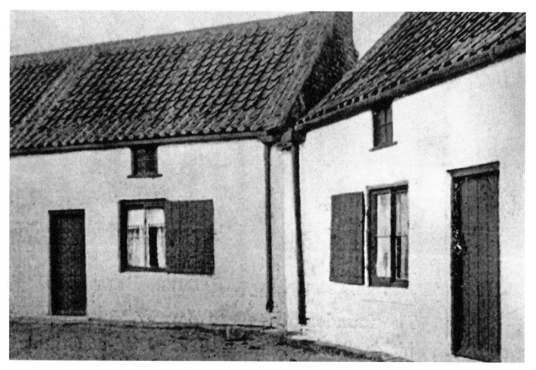

From 1830, there was a tiny chapel nestled between the miners' white-walled cottages in Bede Place, close to High Street. The chapel along with the cottages were demolished around 1934. This photograph dates from 1925.

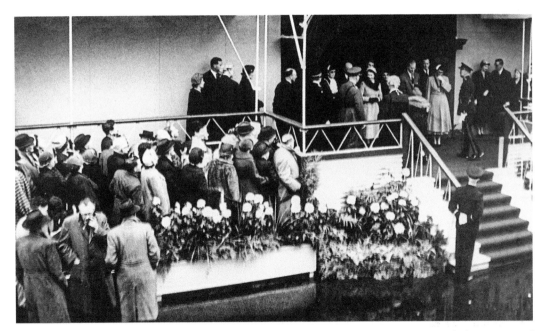

Her Majesty Queen Elizabeth II visited Jarrow as part of her nationwide tour to mark the occasion of her accession to the throne in 1952. She is pictured here with HRH Duke of Edinburgh on the town hall steps with Mayor Emily Coates and civic dignitaries in June 1954. The Jarrow branch of Durham County Constabulary and special constables form a guard of honour for this important and auspicious occasion in the history of the town.

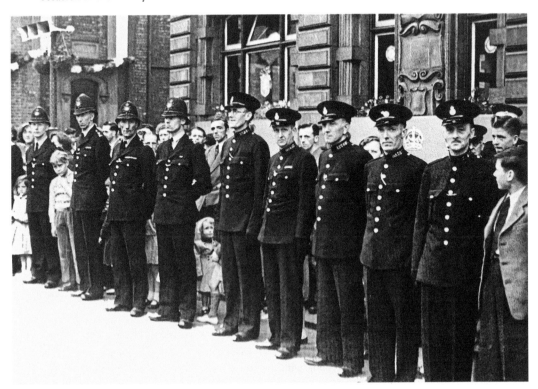

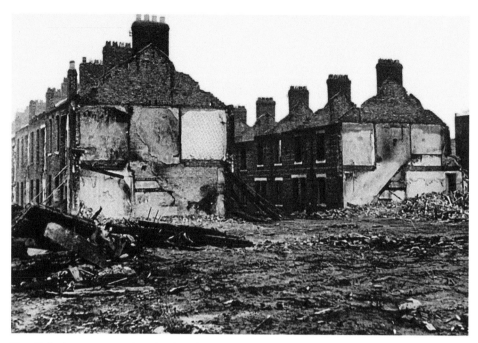

Very little time was wasted as the demolition teams moved in to tear down the many substandard houses in and around the town centre. Pictured here in 1958 are the remains of Gray Street and Burns Street. The property, built in 1875, was swiftly reduced to rubble, and later used for road construction.

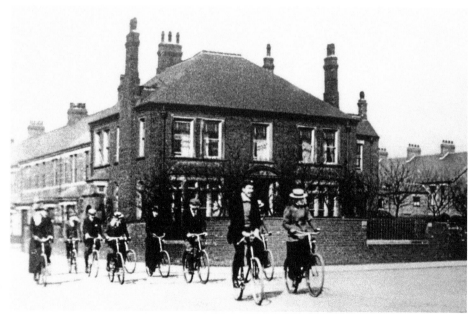

Pictured here in 1910 are members of Jarrow Cycling Club in Bede Burn Road. The imposing nineteenth-century building directly behind them is Fairholme, which was built in 1877. During the 1950s it was converted into hostel-style accommodation for Durham County Constabulary Cadets when Jarrow was chosen for police training. Today the house has reverted back to a private residence.

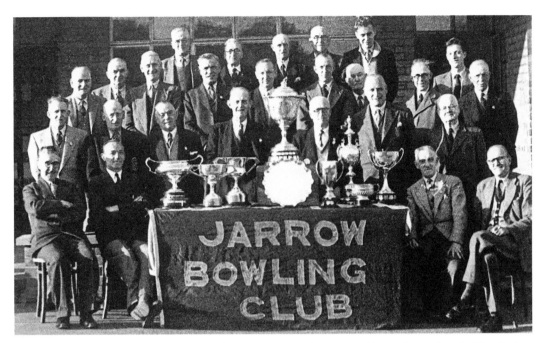

Jarrow Bowling Club proudly poses for the camera with their trophies at the pavilion in West Park at the close of the 1956 season, and Jarrow Corporation bowling team from 1966.

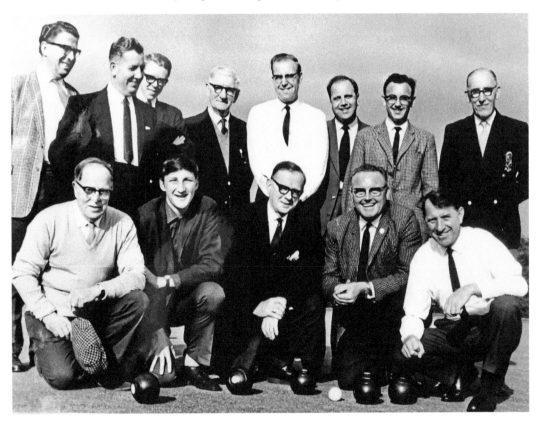

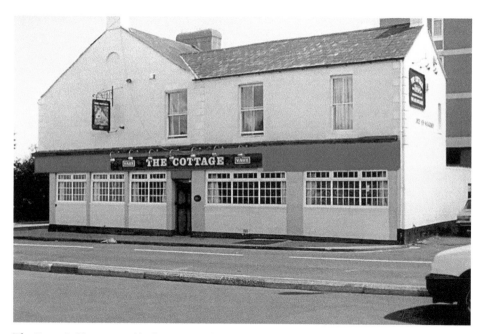

The Forge & Hammer public house in Walter Street dates from 1926. Around this time there was a company with the same name operating from premises in Ormonde Street selling household goods. Both were named as Jarrow prospered as one of the principal industrial towns on Tyneside. During the 1970s, the public house changed its name to The Cottage and remained this way until the property was demolished in 2000.

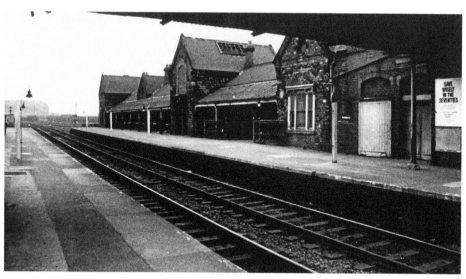

The town's first railway station was in Wylam Street, solely a mineral line carrying goods to and from the paper mill at Springwell and beyond. A joint goods and passenger carrying line operated by North Eastern Railway opened at Grant Street in 1872, and saw service for close to a hundred years. The station was demolished in 1970 and refurbished later in the decade in anticipation of the Tyne & Wear Metro. With the exception of resurfacing, the structure of the platforms remain the same from when the station was built and are still in use. Today the line is still operational but used solely for the Metro system.

The Festival Flats in Cambrian Street in 1970. The eighty-four-property housing complex was demolished in 1982.

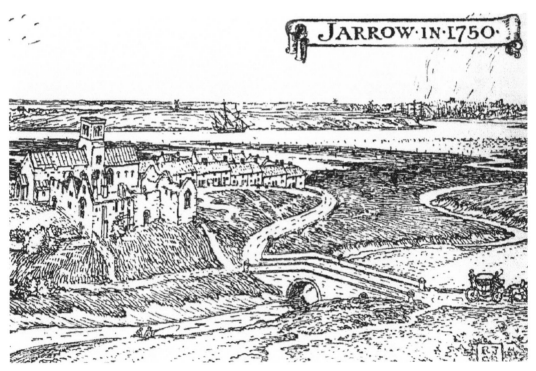

JARROW·IN·1750·

This etching from 1750 portrays clearly how east Jarrow looked around the time of the town's industrial growth.

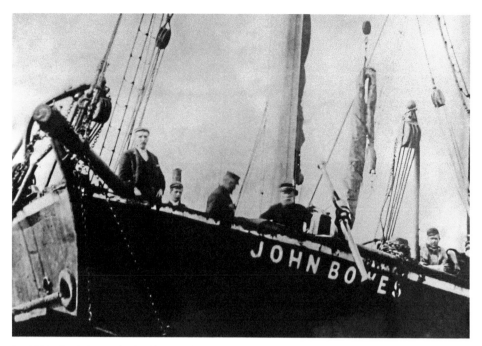

In 1851, the Palmer shipbuilding industry was founded by Charles and George Palmer. Their first vessel that same year was a mere tugboat, but the brothers had great plans and a vision for the future of their investment. The following year, in 1852, the *John Bowes* was launched. This vessel held the distinction of being the world's first collier with an iron screw. After a remarkably long life of eighty-two years, she ran aground in 1934 under the name of Valentin Fierro, off the northern coast of Spain.

Children playing in Newmarch Street, 1950.

The East Ferry Inn, at Quay Corner to the left of this photograph from 1950, played host to the many seafaring men who passed this way when Jarrow was a busy port.

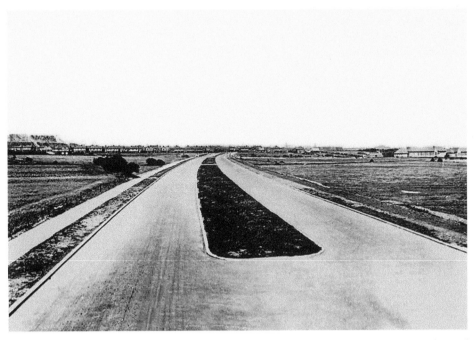

York Avenue was officially opened by HRH Queen Elizabeth, the Queen Mother, Duchess of York, in July 1928, the same day as she launched a ship named in her honour at Palmer's. This photograph was taken in 1928, just prior to the completion of the dual carriageway. Visible to the right is Valley View School, which was completed and ready for the first intake of pupils the same year.

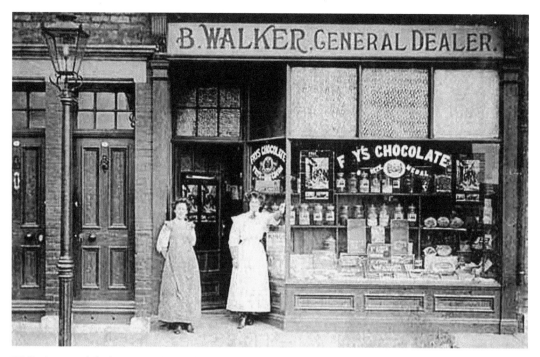

Walker's general dealers in Staple Road is pictured here in this lovely little photograph from 1900. The premises were later occupied by the Jarrow & Hebburn Co-operative Society.